MW00786826

W O M E N
O
W O N D E R

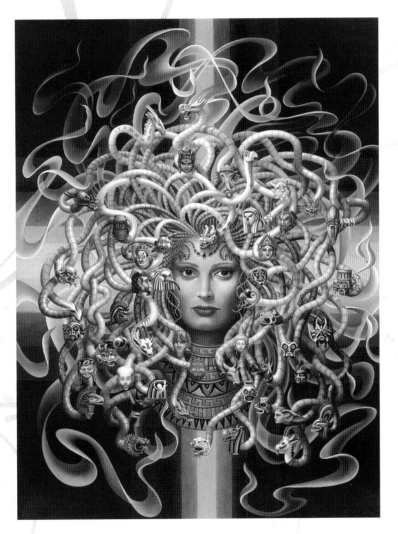

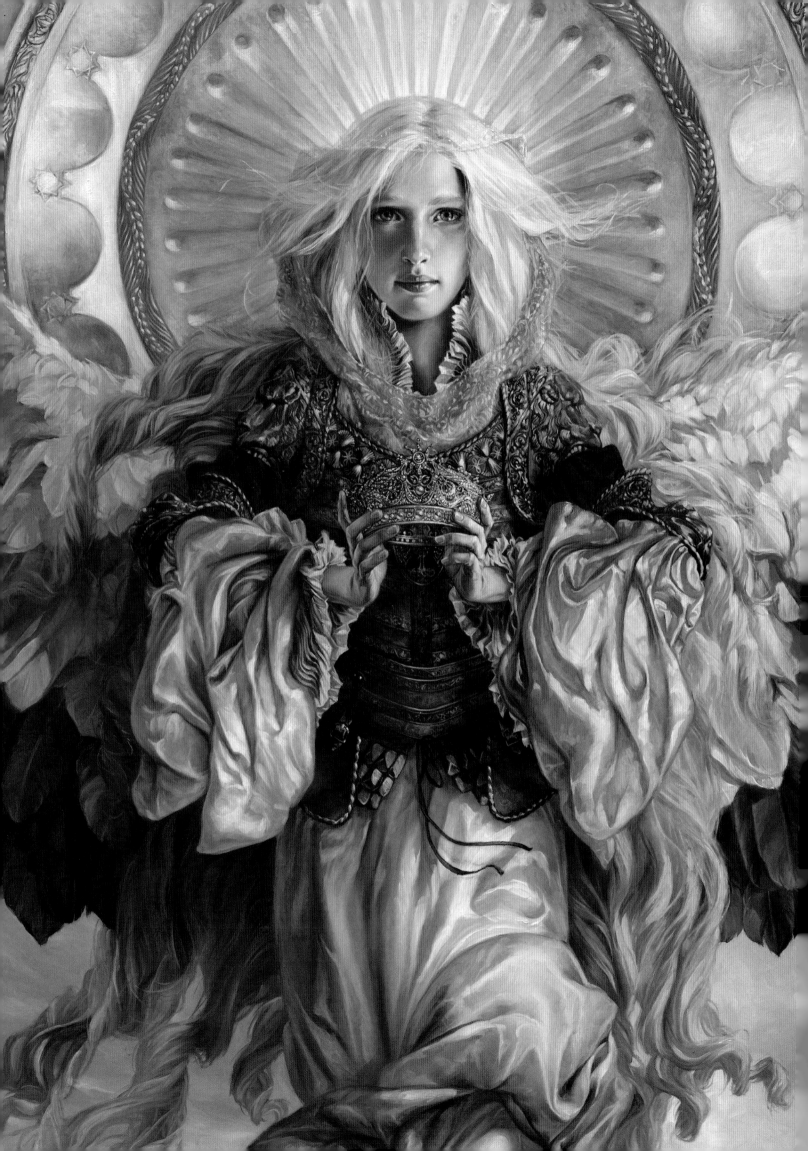

WOMEN of WONDER

Celebrating Women Creators of Fantastic Art

Edited by

CATHY FENNER

UNDER WOOD BOOKS

Nevada City, CA

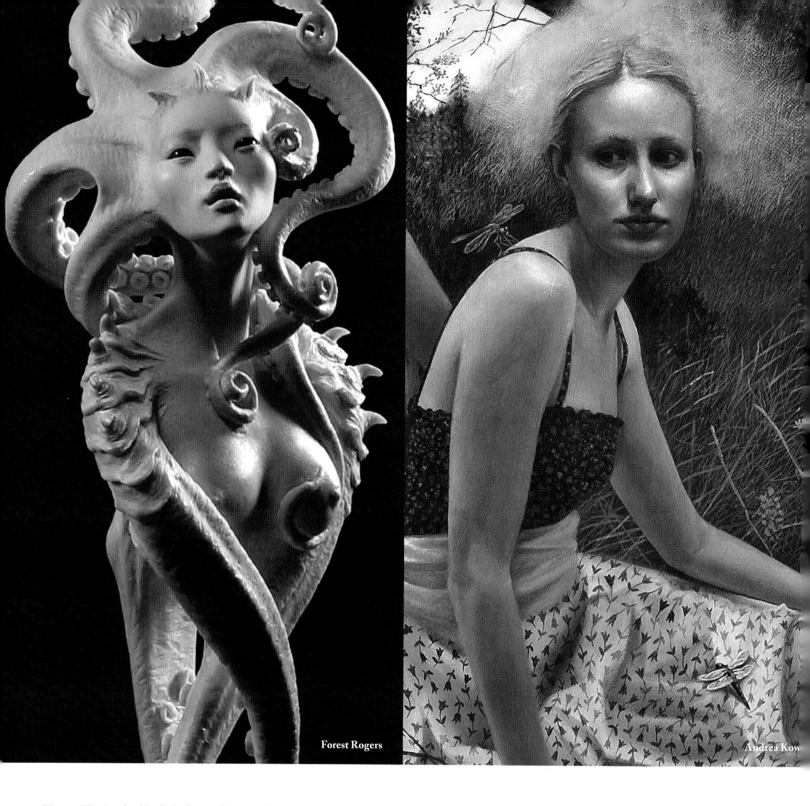

Forest Rogers

Andrea Kow

"Introduction: Women of Wonder" copyright © Lauren Panepinto. All Rights Reserved. Half title page art by Ilene Meyer. Title page art by Heather Theurer. Hardcover endsheet art by Rose O'Neill. Book and jacket design by Arnie Fenner.

Trade Softcover Edition ISBN 978-1-59929-072-0
A limited edition Hardcover Edition not for sale to the public was simultaneously published for the contributors under the same ISBN.
10 9 8 7 6 5 4 3 2 1

UNDER WOOD BOOKS

PUBLISHED BY
UNDERWOOD BOOKS, P.O. Box 1919, Nevada City, CA 95959 www.underwoodbooks.com Tim Underwood/Publisher

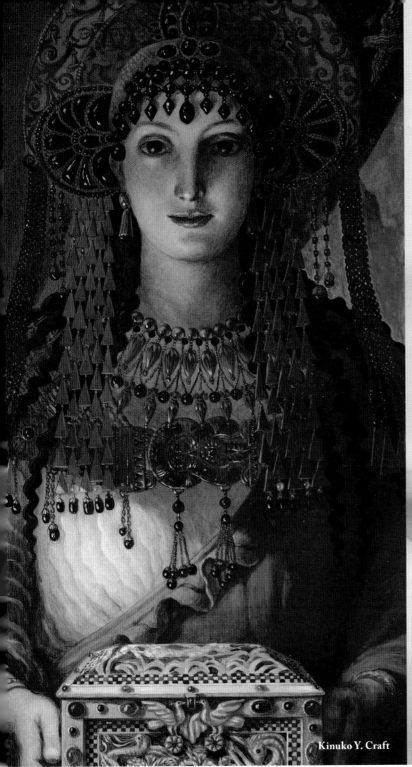

Kinuko Y. Craft

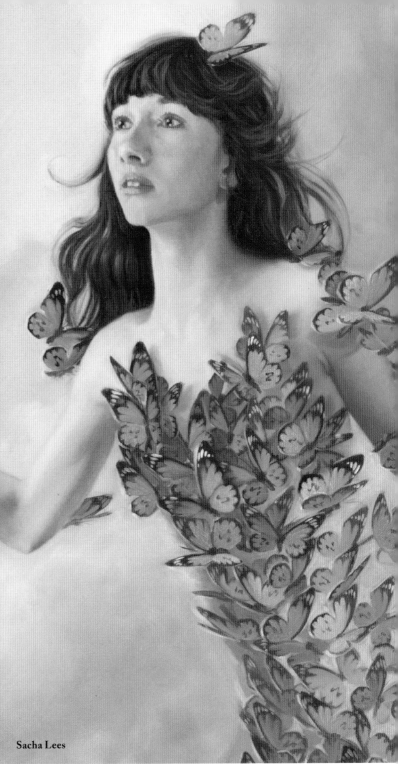

Sacha Lees

C O N T E N T S

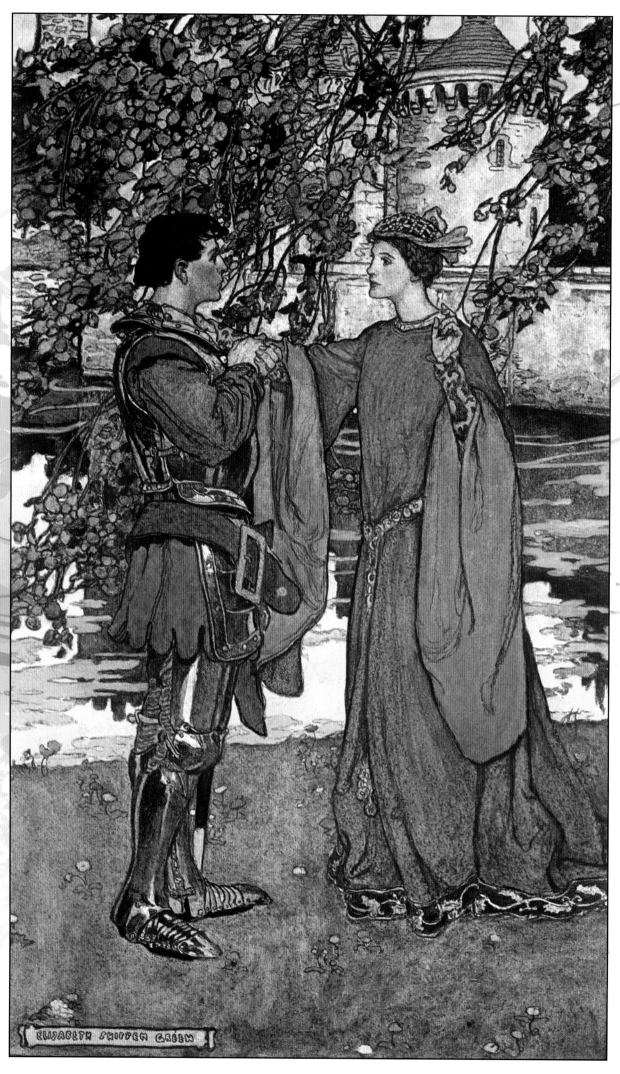

ELIZABETH SHIPPEN GREEN

*f*oreword by
C A T H Y F E N N E R

When people express surprise at the number of women artists working today, I often respond with equal surprise. Not at the numbers, but at people's perceptions and assumptions. It has always been "understood" that the art world in general (and illustration in particular) is a male dominated profession—and it is certainly true that many of the best known painters and sculptors in history *are* men. But for more than a century there have also just as certainly been numerous women who have made their mark and added to the visual language of the culture in this country and abroad. Whether painting for salons and galleries, working in comics, illustrating book covers and interiors, sculpting Fine Art or collectible figurines, or creating greeting cards, posters, puzzles, video games, film design, or apparel, there have *always* been women artists.

The idea for this book has been percolating for a long time. Part of the inspiration stemmed from discovering new work by women artists I was unfamiliar with while my husband Arnie and I were directing the annual *Spectrum* competition. Part came from conversations through the years with friends working in the publishing industry like Tor's Irene Gallo, Orbit's Lauren Panepinto, and Wizard of the Coast's Dawn Murin, all of whom were encouraging and nurturing young talent (of both sexes) and helping to steer genre art in exciting new directions. Part came from sitting in the audience for Winona Nelson's "Women of Fantasy" panel during the Spectrum Fantastic Art Live convention and listening to all of the women on the stage talk about their interests, frustrations, and, above all, passion for creating Fantastic Art. *All* combined to make a collection like *Women of Wonder* inevitable.

Even though any subject can be politicized, this is not intended as a feminist tract. This is not a proclamation or manifesto. As I mentioned above, there have *always* been women in the arts. I worked for over thirty years in the "personal expressions" business for the world's largest greeting card company: over 60% of the creative staff—the illustrators, the graphic designers, the typography artists, the supervisors, the art directors—were women. Looking at *any* aspect of the art world will similarly reveal a long list of significant women creators, past and present, whose influences are deeply felt and, as Lauren mentions in her introduction, whose ranks are growing. If their numbers *seem* surprising, it is partly the blame of historians' failure to see the big picture (again, as Lauren also points out) but is as well a result of people's reluctance to shake off false perceptions. In recent years women artists have increasingly expressed the desire to expand the conversation, to grow the awareness of who they are and what they do; if anything, this book is a reaction to that desire and call to others to join in the dialogue.

Something else this book *isn't*: it is *not* an encyclopedia. There are many, *many* artists not represented in the pages ahead who are worthy and deserving of being in the spotlight whose names I could list just as readily as their fans can (because I'm one, too). This collection could easily be twice the size it is. . . but everything has to start someplace.

So if it's not political and not exhaustive, what exactly is this book? It's a celebration. A celebration of craft, skill, intellect, and imagination. A celebration of determination and originality. A celebration of *Women of Wonder.*

Facing page: "La Fee and Bertrand," a painting by Elizabeth Shippen Green [1871-1954].

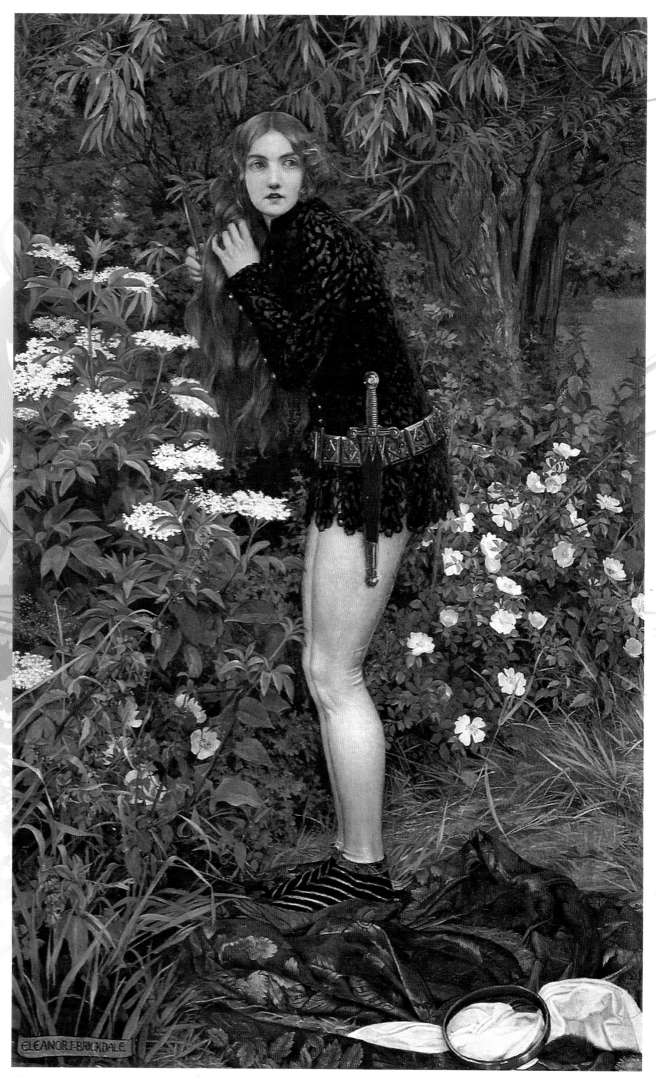

WOMEN
of
WONDER

Introduction by

LAUREN PANEPINTO

I've always found it amusing when people talk about science fiction and fantasy as a relatively modern invention. Was Jules Verne the first author of science fiction? Was it Mary Shelley? Were the Pre-Raphaelites the first fantasy artists? Does the movement we call "Fantastic Art" start with illustrations for the Gothic novels of the eighteenth century, or not until the Pulp Era in the twentieth century?

I think we're not only looking at the wrong centuries, but at the wrong geologic age. I believe we have to go back to the roots not just of civilization, but of humanity itself to find the beginnings of "Fantastic Art." Around ancient campfires, the first humans tried to explain the universe using their imaginations, creating gods in their own image. They saw thunder and lightning and volcanoes, and created stories to explain them. Now we call them myths. Seen in this light, is there that much difference between the ancient myth of Zeus and the modern myth of Superman? J. R. R. Tolkien himself said that he did not set out to write a fantasy trilogy, but instead to create a new mythology for his beloved Britain. Myths and fantasy and science fiction all spring from the same well of imagination.

Anthropology tells us these pre- and proto-literate cultures were often led by priestesses, and female deities were supreme in their pantheon of gods. Archaeological evidence proposes that women were the makers and keepers of myth in those Stone Age civilizations. Those times are shrouded in the dense mists of history, but it is very possible that the oldest art we have — painted on the walls of caves — was religious and fantastical and was very likely created, at least in part, by women. I find it fitting to recall this as we embark on a tour of modern women mythmakers and visual storytellers.

Over time, our cultures and our civilizations shifted to a more patriarchal view. Although women continued to participate in both the fantastic and artistic, the spotlight mostly belonged to men. We are only recently unearthing and lauding the lives of women like Artemisia Gentileschi and Camille Claudel, who fought uphill battles to carve out careers in art for themselves. Women never stopped

Facing page: "The Little Foot Page," a painting by Eleanor Fortescue-Brickdale [1871-1945].

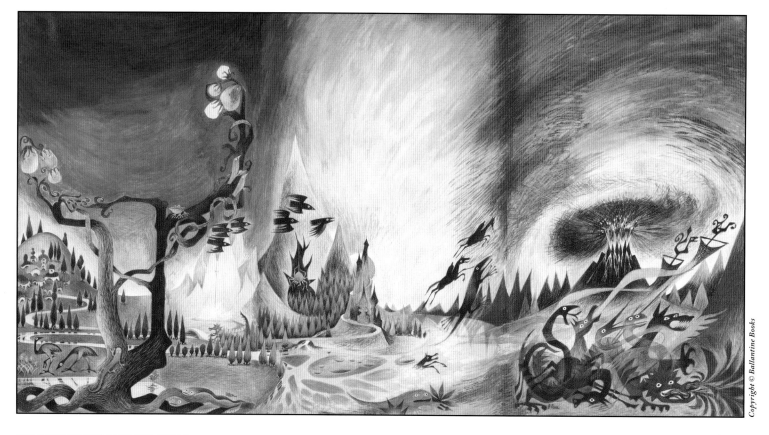

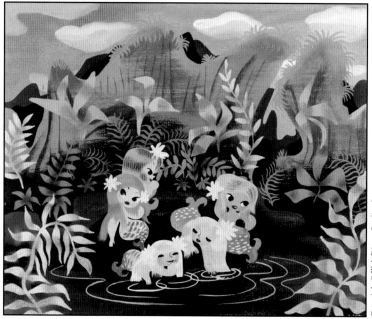

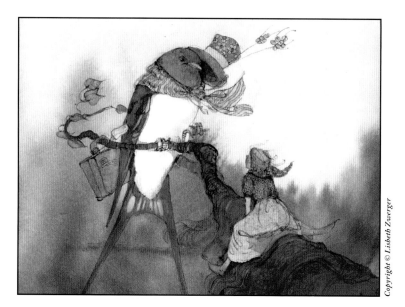

Top: Barbara Remington's painting which was divided into the three covers for the Ballantine 1965 paperback editions of the *Lord of the Rings* trilogy. *Middle left:* A sample of Mary Blair's concept art for Walt Disney Studios' *Peter Pan. Bottom left:* One of Lisbeth Zwerger's paintings for a 1988 illustrated edition of *Thumbelina. Above:* Painting by Alicia Austin. Alicia was the first woman to win the Hugo Award for "Best Fan Artist" (described as the science fiction field's Oscar®) in 1971, the same year that Diane Dillon received the "Best Professional Artist" honor.

making art, but the writers of history often overlooked their accomplishments.

In the last few generations we have seen our society inch closer and closer to equality between the sexes in many areas, and yet women who were artists with successful careers still remained the exception. There are many debates over why this has been the case — societal pressure, sexism, the responsibilities of motherhood, a lack of self-confidence — the same arguments about women dropping out or "leaning in" in any career also apply to art.

As an Art Director, it is my job to know all the up and coming talent in my field. In the six years I have been at Orbit Books, and specifically commissioning Fantastic Art, I have reviewed countless portfolios and met hundreds of artists at all stages of their careers. I am in a perfect position to observe the deep currents of change that move our field. In recent years, it feels like the gender ratio in the art world is shifting. I look at this newest generation of artists working in Fantastic Art, recently graduating and now trying to establish their careers, and women are not only present, they are definitely no longer the exception. I see young women refusing to accept the sexism in our genre. I see them choosing to have children *and* careers. I see them decimating the antiquated clichés of what subjects "lady artists" are allowed to paint. And if you talk to these young artists, they immediately name the women who serve as their own artistic heroes – the ones a generation ahead of them, who showed them the way. These women don't question their right to a place in the world of Fantastic Art because of the trailblazers who fought for a woman's right to prosper in this genre. For every Karla Ortiz and Rovina Cai and Rebecca Yanovskaya there has been a Kinuko Craft and a Terryl Whitlatch and a Rebecca Guay who forged the path, and who are still shining the light on the road ahead.

Seeing the art of so many talented women collected together in one book, we can really begin to appreciate how the feminine point of view colors the world of Fantastic Art. Although there are a wide variety of styles and subjects represented, there are also many points of similarity from which common ground emerges. In a genre often overpowered by the male perspective, this book offers us a unique opportunity to savor how distinctive and wonderful the fruits of a female imagination can be.

I myself am a female artist and I have idolized many of the women in this book. As much of a geek as I was growing up, it wasn't until I saw these women's names on book jackets and trading cards and comic books that I realized I, too, could make a career for myself in art. The fact that I also came to work in the realm of Fantastic Art, and that I can commission many of my idols, is a dream come true. It was a dream I cultivated back in the days when I was trying to learn to draw by copying Jody Lee's book covers and Rebecca Guay's *Magic: The Gathering* cards. Without many of the women in this book, I would never have been inspired to find my own career in art, and it is an honor to introduce them and this collection.

It is important to celebrate the women who have already established successful careers in Fantastic Art — careers that are still going strong — and it is a tribute to them that in the same book we highlight the younger careers they have inspired.

Lauren Panepinto

Creative Director, Orbit Books, Yen Press, Redhook Books

Above: "King Kull" by Marie Severin. Marie began as colorist for the legendary EC Comics in the 1950s and eventually became production head for Marvel. She collaborated with her brother John on Marvel's acclaimed *Kull the Conqueror* comics, she as penciler and colorist, he as inker. *Below:* "Night Demon & Fire Girl" by Rowena Morrill. Rowena first gained attention in the late 1970s and became one of the most popular cover artists in the F&SF field.

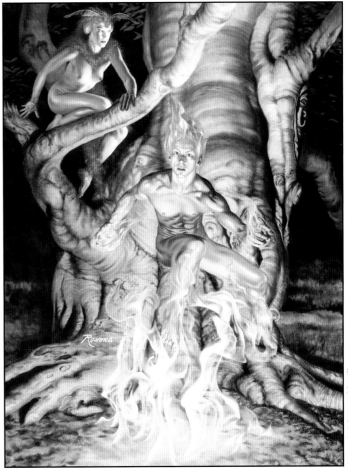

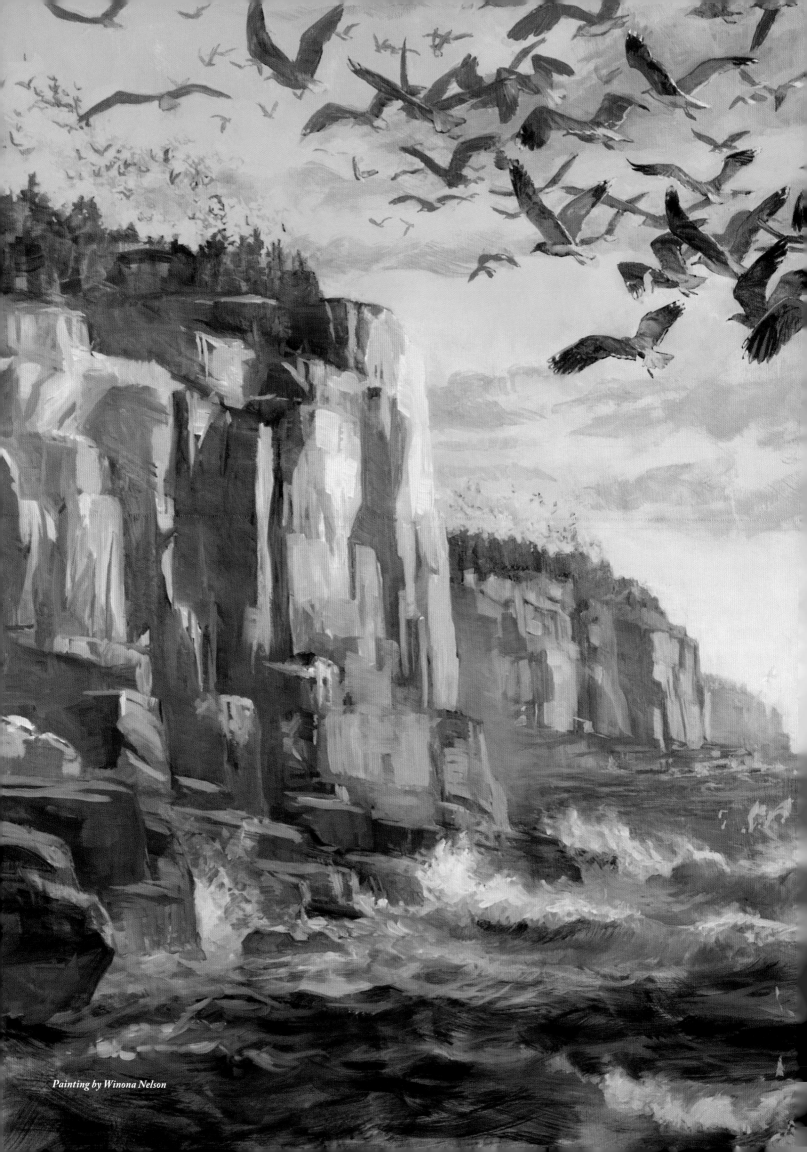

Painting by Winona Nelson

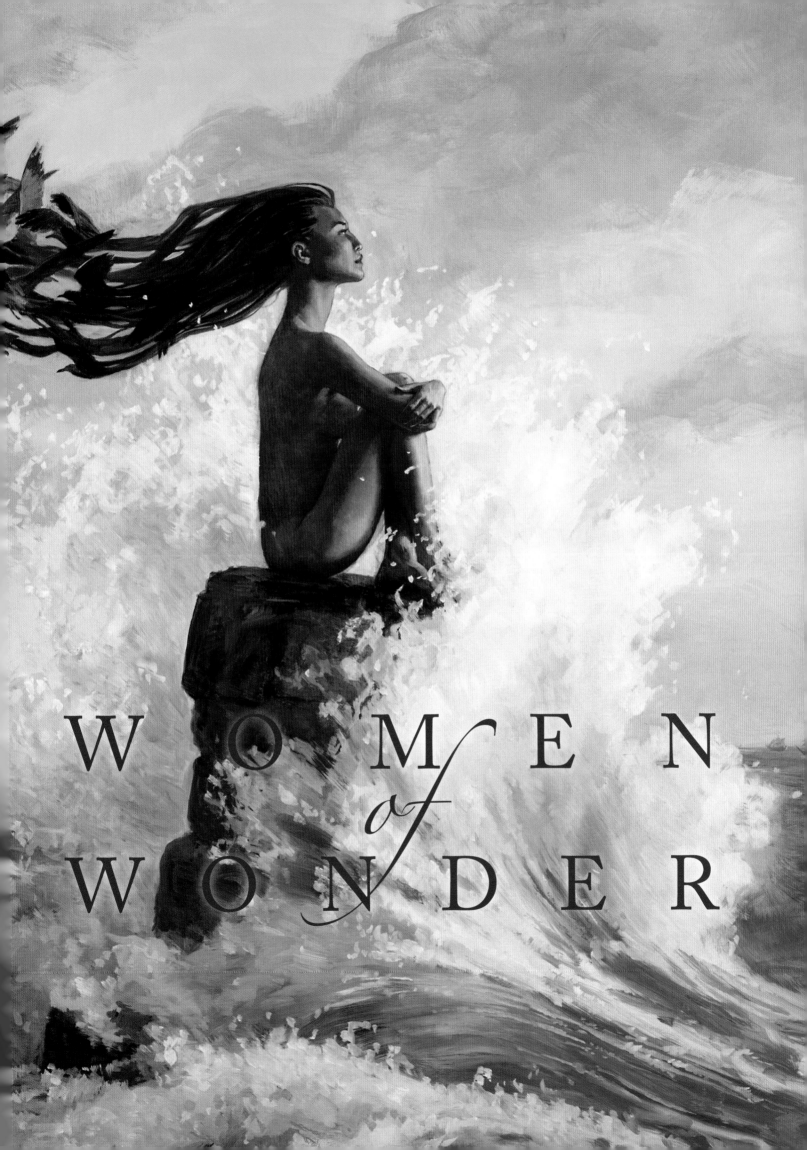

Kei Acedera

"To show another your wildest dreams in your own fantasy art is to invite them to see into other worlds where the sky is the limit, and the stars are in reach. A force for positive change that might otherwise never be expressed might lie in the terrifying jaws of a dragon, or the tranquil embrace of a mermaid. How fun it is to lay paint to canvas and touch the minds of countless people you might never otherwise meet, to show them that life really is fantastic!"

—*Kei Acedera*

Sheridan College for Animation
Art Director: Imaginism Studios

www.imaginismstudios.com

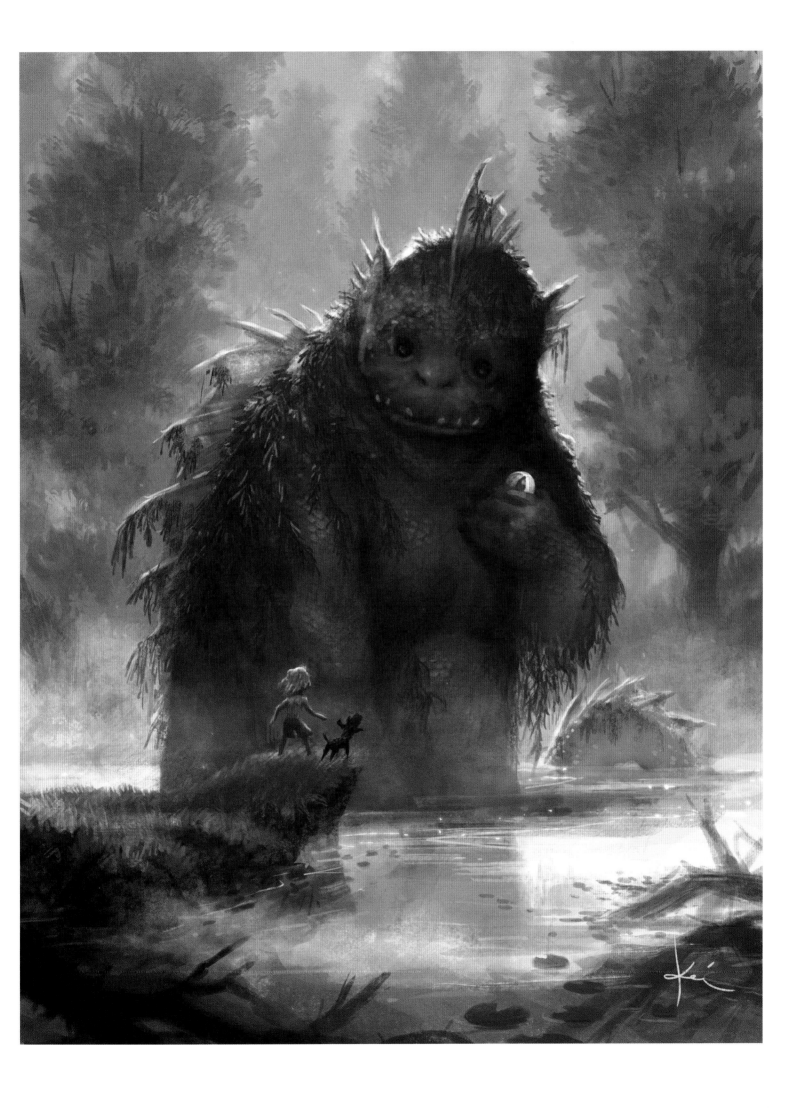

Mia Araujo

"I grew up loving imaginary worlds, history, fairy tales, and mythological characters. Fantastical stories and paintings were what excited me as a child, and made me want to become an artist.

"Today I focus on painting the invisible, but powerful forces at work behind each character—the memories, emotions, desires, dreams, and demons that drive them. The most powerful forces in the universe are invisible to the naked eye, so it takes a pinch of fantasy—a suspension of belief—to see them realized. Through this imagery, I strive to create a modern mythology for each of my characters that connects them to nature and the cosmos.

"I believe that an entire universe exists within each person, and it is my hope that looking at my work will awaken the desire for self-exploration within the viewer."

—*Mia Araujo*

Otis College of Art and Design Valedictorian

www.art-by-mia.com
www.facebook.com/mia.araujo
Instagram/com/mllemia
Twitter.com/mllemiaaraujo

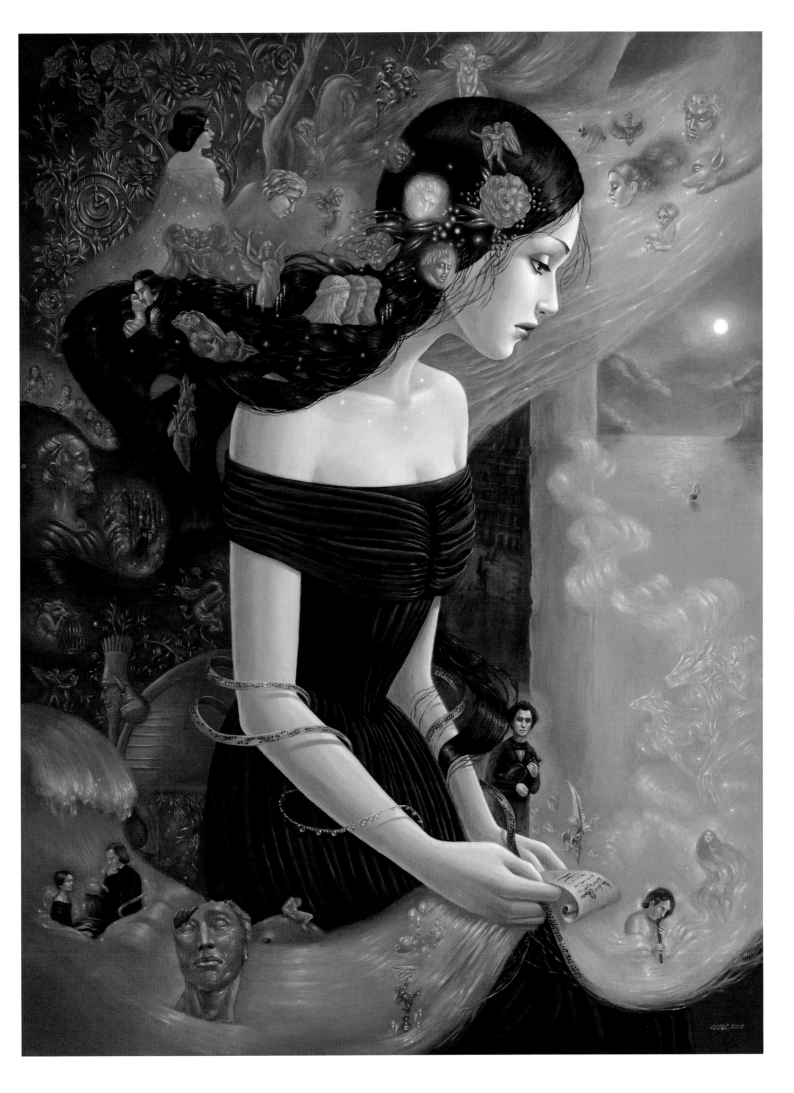

L.D. Austin

"It may surprise you to learn this, but I was one of the geeky kids at school. I lived in a small town in the woods of rural Canada and none of the other kids my age were really into old *Dragonlance* novels, dinosaurs, and cheesy 80's fantasy movies. They all thought I was a weirdo (correctly, as it turns out). My experiences talking to other artists leads me to think that this is not an uncommon childhood for our folk.

"At the same time, I loved realistic art. The 19th Century painters like Rosa Bonheur and John Singer Sargent were masters of light and form. The 20th century illustrators like Rockwell and Pyle were not only technically adept, but their ability to tell a complex story in a single image captivated me.

"For me, James Gurney's *Dinotopia* brought it all together. Those dinosaurs felt like real animals. They inhabited the paintings so completely with the human characters. Later I found the work of Terryl Whitlatch, whose drawings of mythical and extinct animals blend so perfectly with real living ones that you always have to look twice to make sure you know which ones are which. I knew that I wanted to do that, to make the fantastic into something that felt real. I'm still on my way to that goal, but considering how deeply such work spoke to kids like me, it feels like it's a worthwhile road to travel.

"Being an artist isn't easy. We all go through our ups and downs, and inevitably the moment you take a couple steps ahead, you realize you weren't anywhere near as close to the goal as you thought you were. So try your best, and don't let the world get your goat."

—*L.D. Austin*

Nova Scotia College of Art & Design BFA
Senior Illustrator: Blizzard Entertainment

www.laureldaustinart.com/blog/
ldaustinart.blogspot.com

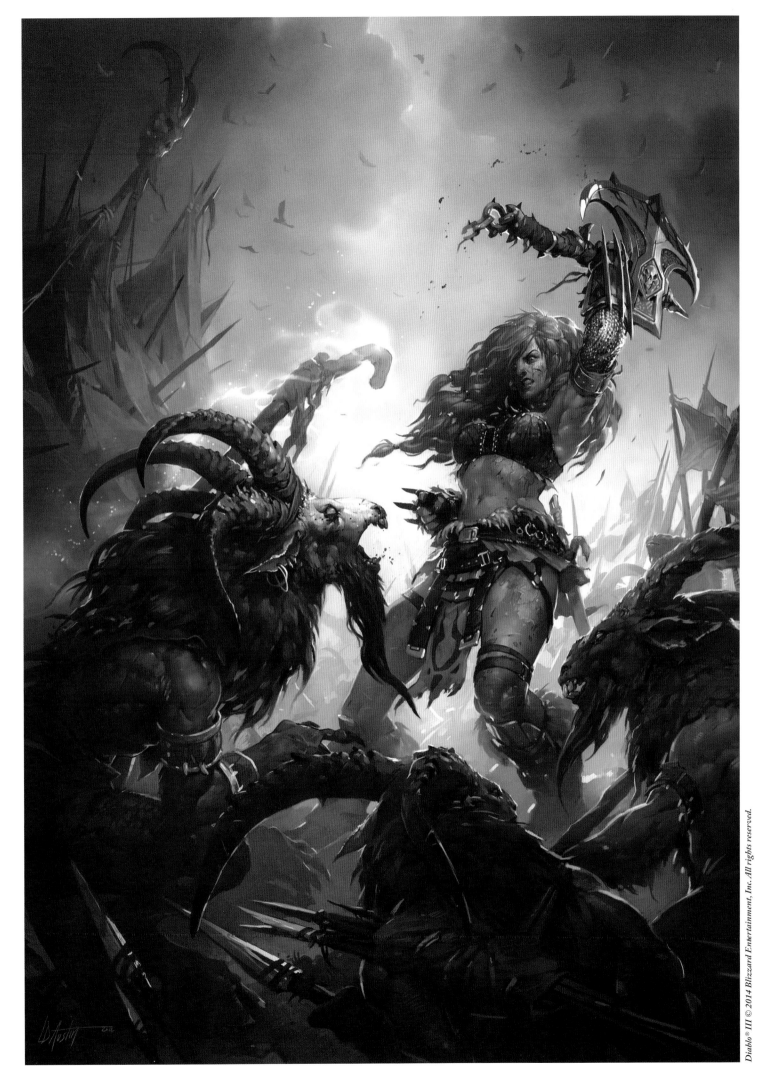

Anna & Elena Balbusso

"We are identical twin sisters. We have been drawing since three years old. Our passion for art is born from an early age, from elementary schools. Our natural choice for high school was the art school "Liceo Artistico G. Sello" in our hometown of Udine in Italy. Five years of study concentrated on art, graphic design and photography. But our desire to concentrate on painting and illustration drew us to Milan and concluded with a diploma in painting at the Academy of Belle Arti of Brera. We continued our education at the Università Degli Studi di Milano studying art history, modern literature, history and philosophy for another two years.

"We have been working as an artist team with a unique signature since 1998. Our style has developed gradually from our collaboration. It is a continuous investigation and naturally evolves.

"Gradually we developed a personal style where traditional painting and tools were combined with digital programs, however we chose not to use the virtual paint brushes. Our individual brush strokes are handmade and then scanned. The final result is like a painting on paper or on canvas.

"We do not work in series, but each project is unique and not repeatable. Every story has its image with its colors and atmosphere. We love the warm colors, very intense and dark as in the paintings of the greatest masters, but we change the palette constantly moving from one project to another. Our inspiration comes from art in general from Ancient Rome mural painting (frescoes at Pompeii) to Modern Art and Contemporary Art. Before starting an assignment it is very important [to do] the research, create an archive of sources. In our fantasy art, dreams, surrealism, symbolism, gothic atmospheres mix together and combine."

—*Anna & Elena Balbusso*

Represented in the United States by Shannon & Associates, Inc

www.balbusso.com
www.facebook.com/balbusso.twins
www.behance.net/balbusso

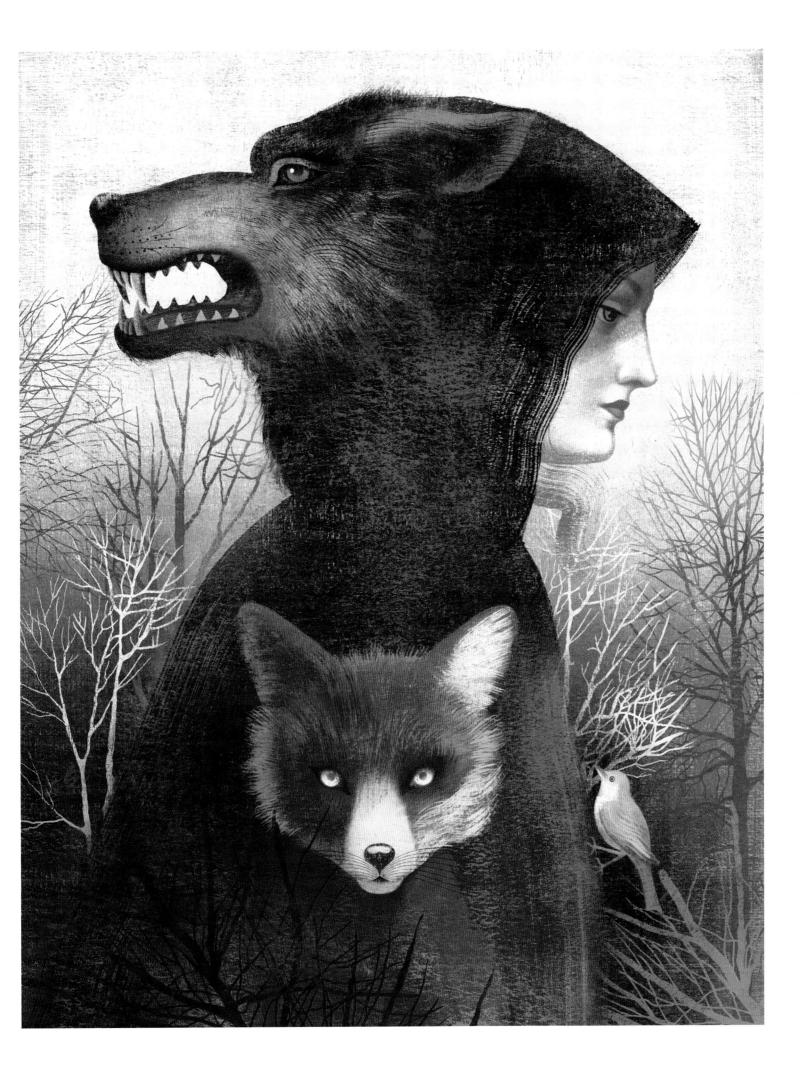

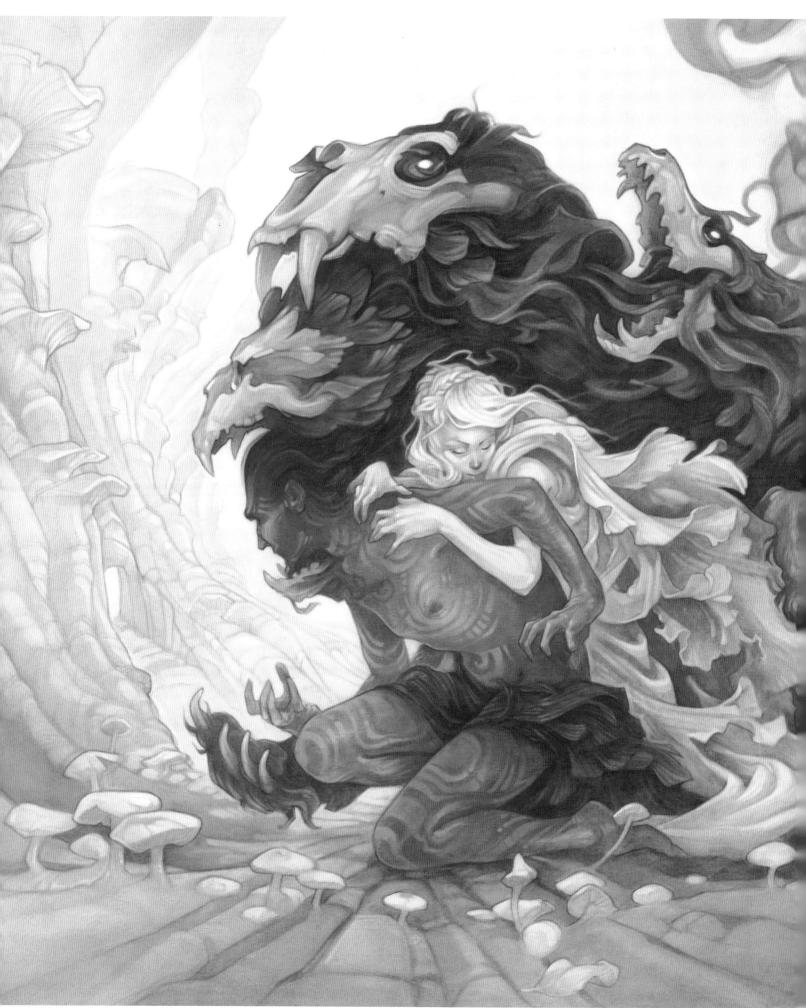

Wylie Beckert

"I view illustration (that inhabitant of the much-maligned world of commercial art) as a medium with amazing storytelling potential, capable of equalling fine art on every level.

"I work in both digital and traditional media—incorporating pencil linework, ink, oils, and transparent layers of digital color to create paintings with flowing lines, rich textures, and a dramatic balance of light and dark. The simultaneously grim and playful images I create are distinguished by vivid characters and an emphasis on narrative, offering a window into a world that is both sinister and inviting. My work has most recently found itself in books, card games, magazines, and advertising, but is at home anywhere there is a story to be told or walls to be adorned."

—Wylie Beckert

www.wyliebeckert.com

Jasmine Becket-Griffith

"My interest in Fantastic Art began at an early age. I discovered the world of Dungeons & Dragons, TSR books and gaming art when I was in middle school. I received the book *The Art of the Dragonlance Saga* for my 12th birthday and it left a huge impression on me. It was a revelation seeing the works & biographies of artists whose sole job was creating fantasy art; it struck me that it had to be one of the most fun jobs in the world. Having followed that path myself I still would have to agree. For me, subject matter, story and theme are integral to the beauty of a painting—anything that provokes thought, discussion, whimsy. I enjoy having the freedom of painting the world how I want it to be."

—*Jasmine Becket-Griffith*

Book: *Strangeling: the Art of Jasmine Becket-Griffith* [**New Leaf**]

www.strangeling.com
www.facebook.com/strangeling

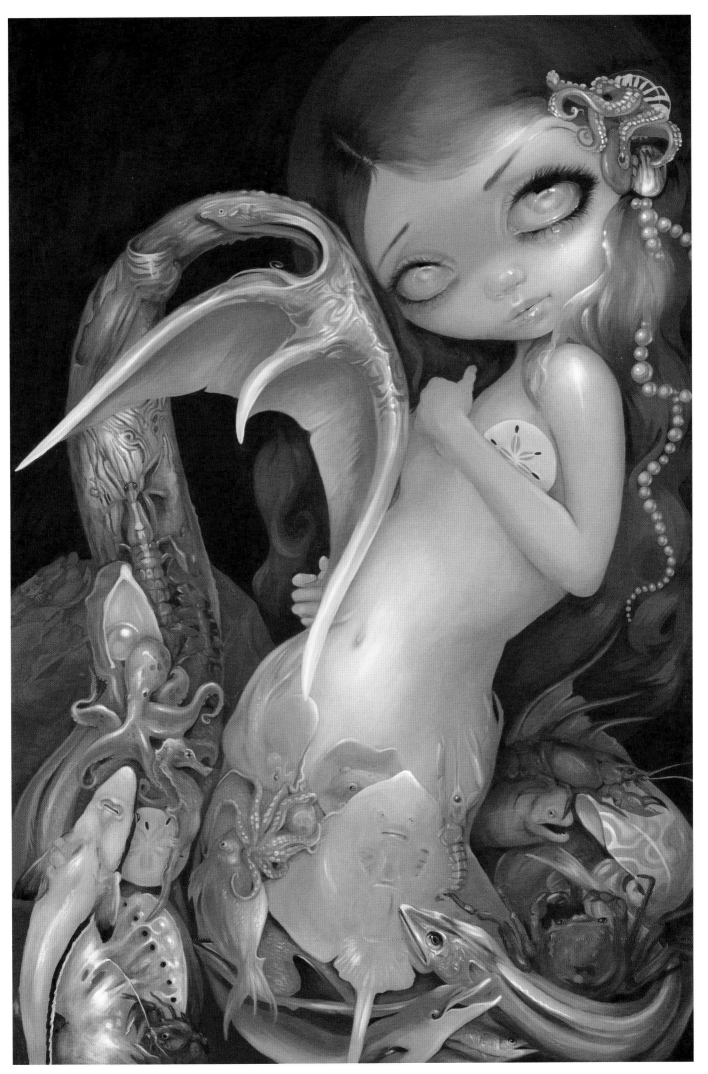

Kelsey Beckett

"In fantastic art, anything is possible. Any mystery can be explored and every compulsion can be satisfied. My paintings serve to expose people to their own discomforts with ugliness in comparison to beauty. Most works contain a subject of ethereal elegance, haunted with detachment, distortion, and discomfort. These grotesque themes can be inspired by tragic events in everyday life as well as from nightmarish and fantastical visions. I feel a compulsion to match beauty with ugliness and discomfort, as they both serve to compliment and agitate each other endlessly. Complete symmetry of the two is possible and constant throughout life, and I hope to capture it fully one day in my work."

—Kelsey Beckett

The College of Creative Studies graduate

www.Kelseybeckett.com

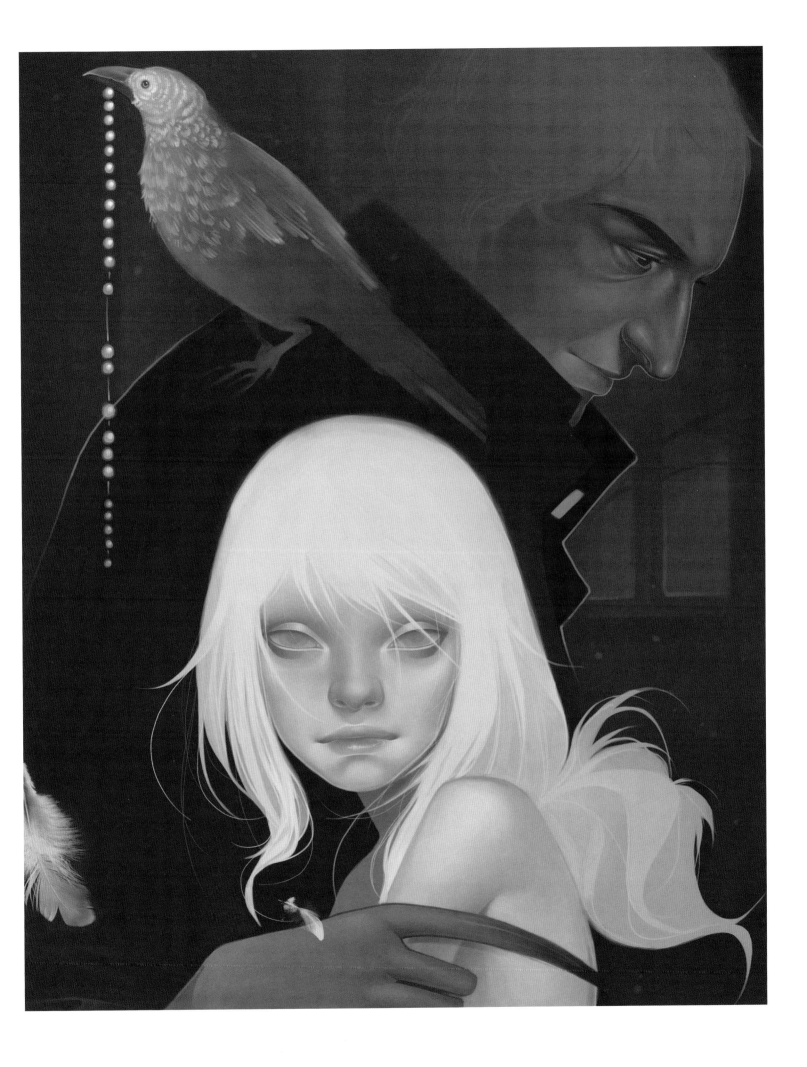

Laurie Lee Brom

"My first introduction to 'fantasy art' came many years ago. I'm not going to give you the date, but I will say that the women's restrooms were always unoccupied while there was always a line snaking out of the men's. This represented the ratio of men to women at every con I attended for many years. The art represented at those conventions and throughout the field of art was very much from a male perspective. Things have certainly changed.

"I could not be more thrilled to be included in this compilation of female Imaginative Realists. It's a great time for this field in general, with our brand of art seamlessly flowing between galleries, publishing and entertainment. But it's especially satisfying to see so many women having strong voices in this field, both as artists and as patrons of the art.

"My art is reflective of the things I've been interested in since childhood— ghosts and legends, flora and fauna, and all things vintage and everything creepy. I grew up in Charleston, SC, surrounded by all these things. I studied illustration at Parsons, took a long sabbatical to raise kids, and returned to my love of art and illustration around 2010 with a burning need to make up for lost time."

—*Laurie Lee Brom*

www.laurieleebrom.com
www.facebook.com/lauriebrom

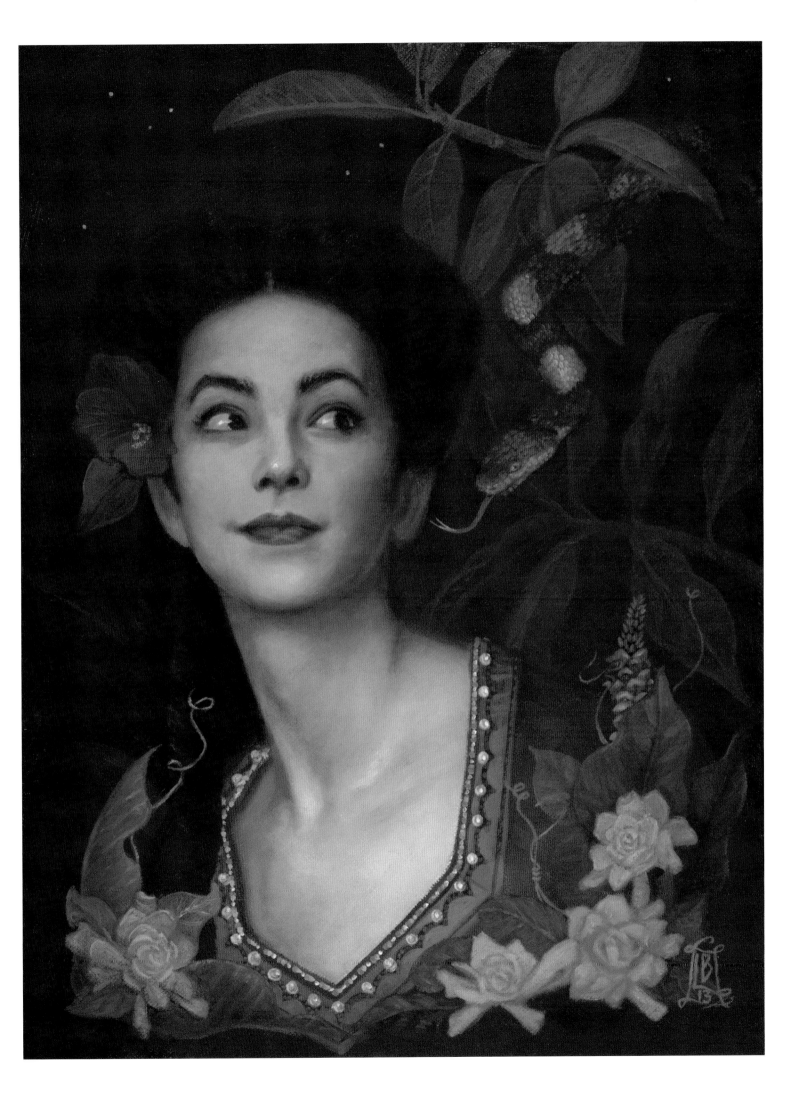

Margaret Brundage 1900-1976

"Once in awhile I would have a friend pose for me. But mostly it was out of my head. And, for the male figures, I would pick my husband to pose for a while. But to hire models, no, I'm afraid I didn't. But I did give them the impression that I did hire models. But I never came right out and said 'I hired a model.' But if they thought I had a live model, it would cause me less trouble with anatomical problems."

—from an interview with Margaret Brundage by R. Alain Everts talking about working for the pulp magazine Weird Tales

Chicago native and classmate of Walt Disney, Margaret Brundage was a prominent (and virtually only woman) illustrator for the pulp fiction magazines of the 1930s. *Weird Tales* was her major client and she produced 66 pastel covers for them over a 13 year period. Many of her pieces featured nudity and women in various states of peril, but she was also the first artist to illustrate Robert E. Howard's Conan the Cimmerian in color.

Book: *The Alluring Art of Margaret Brundage—Queen of Pulp Pin-up Art* [Vanguard Publishing]

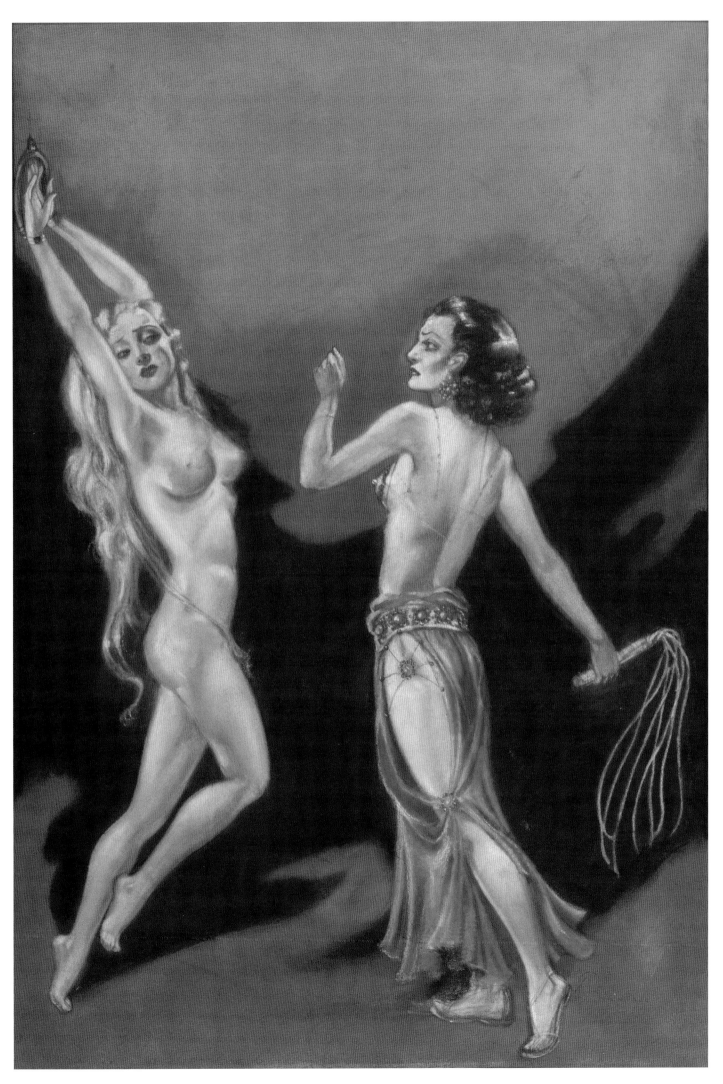

Marina Bychkova

"I was born and lived in Siberia, Russia until I was fourteen years old. In 1997 my family immigrated to Vancouver, Canada where we've lived ever since. My fondest memories are of beautiful rolling hills and forests of Siberian countryside where I spent my childhood, as we lived on the outskirts of the city and had a little cottage in the county overlooking a huge river valley. The scenery alone was inspiring enough to create beautiful things but I can't pinpoint the exact event or time which sparked my interest in dolls. It was always there as far back as I can remember, as if it was innate.

"The reason I love making dolls is because it's such a multidisciplinary art form. I'm not content working in just one medium such as painting or sculpture, and dolls offer me a very diverse and satisfying tactile experience. To create a doll I get to do it all: sculpture, industrial design, painting, engraving, mold-making, drawing, metalwork, fashion and jewelry design. I want it all, or nothing!"

—*Marina Bychkova*

Emily Carr Institute of Art and Design graduate
Book: *Enchanted Doll* [Baby Tattoo]

www.enchanteddoll.com
www.babytattoo.com

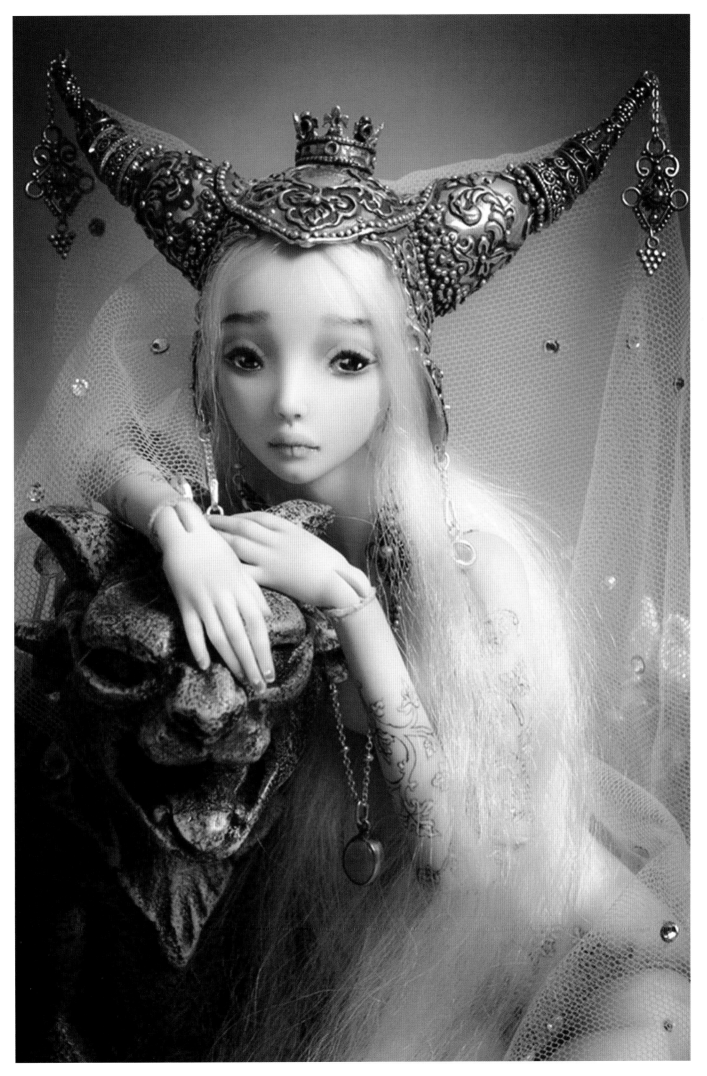

Rovina Cai

"I am inspired by looking at the past, especially at mythology and fairy tales. I search for ways to relate my own experiences with these stories, and to reinterpret them in the context of the present day. These tales were often filled with darkness and magic, and sometimes quite strange; there is a sense of intrigue in the dark and surreal that holds your attention and asks to be examined. Working with this kind of imagery allows me to explore things that are hard to express with words, like a half remembered dream or nostalgia for places and memories that are not quite real. It is a world of subtleties and ambiguities that deals with things deeply felt but not easily seen on the surface."

—*Rovina Cai*

RMIT University in Melbourne degree
School of Visual Arts MFA

www.rovinacai.com

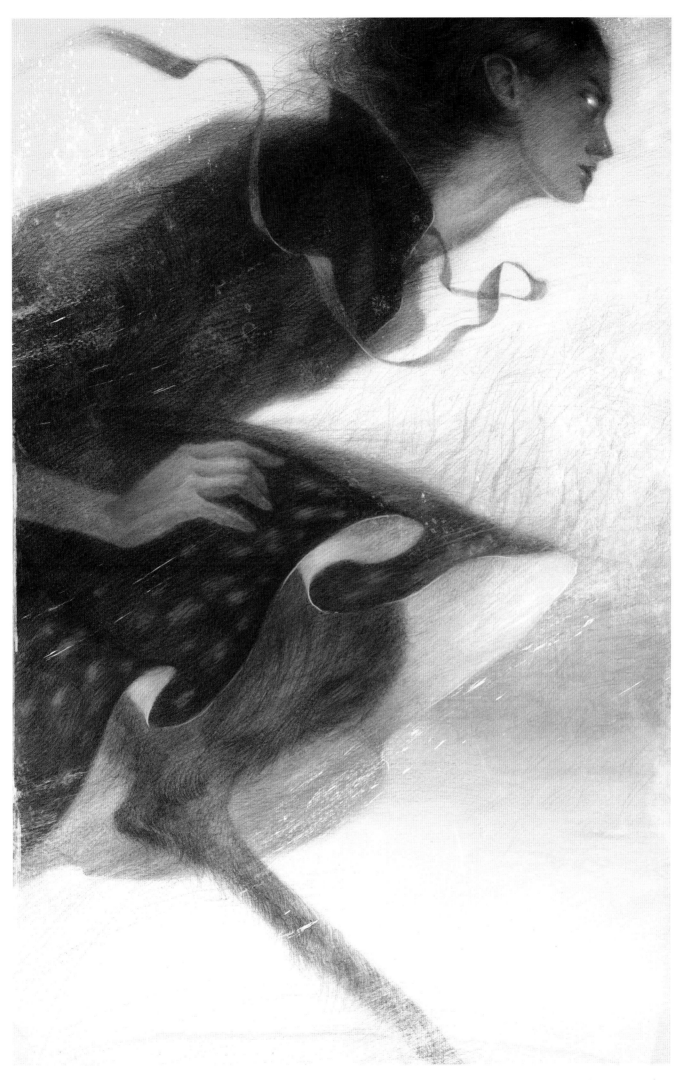

Kristina Carroll

"Since my mother first read me *The Hobbit,* I have been in love with fantasy. As an only child of two working parents, I grew up with Tolkien, *Dragonlance* and Gaiman shaping my view of the world more than school or family and wouldn't have it otherwise. After spending so many hours alone drawing my favorite characters from books, comics and D&D games, it is a great privilege to have joined the community that inspired the younger me to dream. As an artist and a teacher, I am very grateful to be in a position to share my love of art and fantasy with others and am still inspired on a daily basis by those I now call my peers.

"Currently, my work is heavily influenced by the Symbolist movement and all manner of imaginative storytelling, both old and new. I'm especially drawn to mythology, archetypes, metamorphosis and how those themes can be translated into modern narratives."

—*Kristina Carroll*

School of Visual Art BFA/Honors graduate

www.kristinacarrollart.com

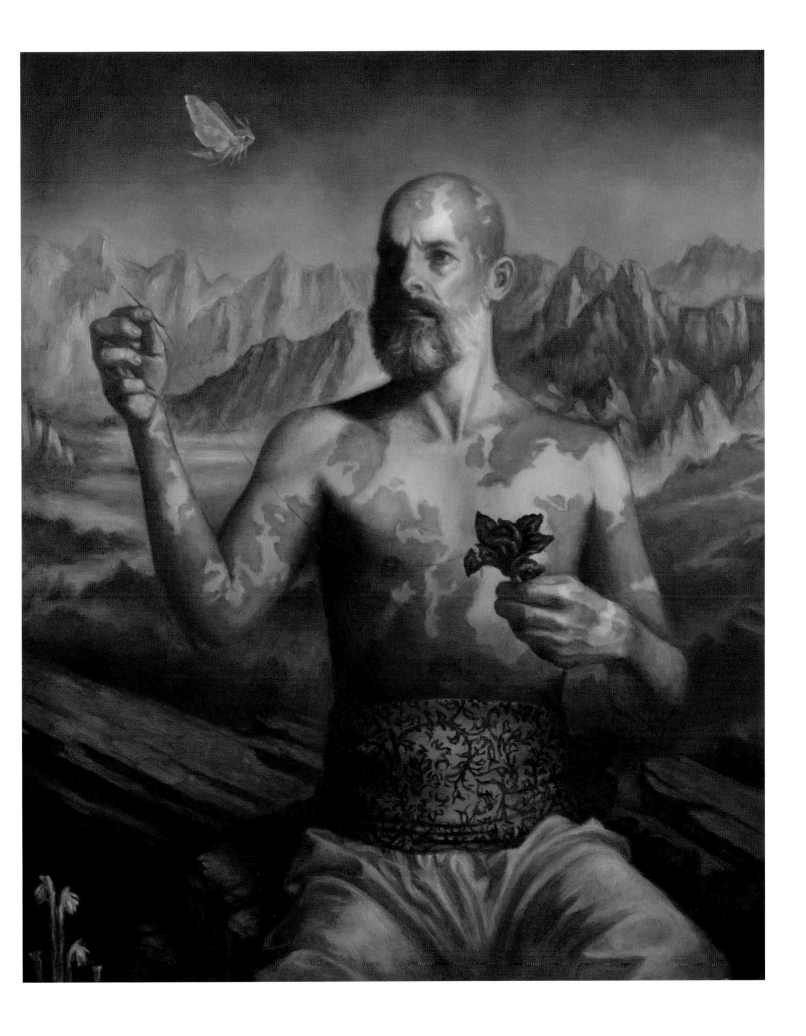

Echo Chernik

"I've always loved to both draw and solve problems—and when I was in school, wanted to either go into medicine (brain surgery specifically) or illustration (drawing to communicate a message/solve a problem). I deduced that my artistic talent was stronger and I chose to honor it by dedicating myself to a career in illustration.

"I strive to celebrate the beauty in the differences of individual women. Each of my figurative art nouveau illustration celebrates an individual woman and presents her, not just as an object or form, but as a unique personality. I especially appreciates the spectrum of beauty found across all cultures and ethnicities."

—*Echo Chernik*

Pratt Institute graduate Summa Cum Laude
Book: *Echo a la Mode* [Echo-X, LLC]

www.echochernik.com

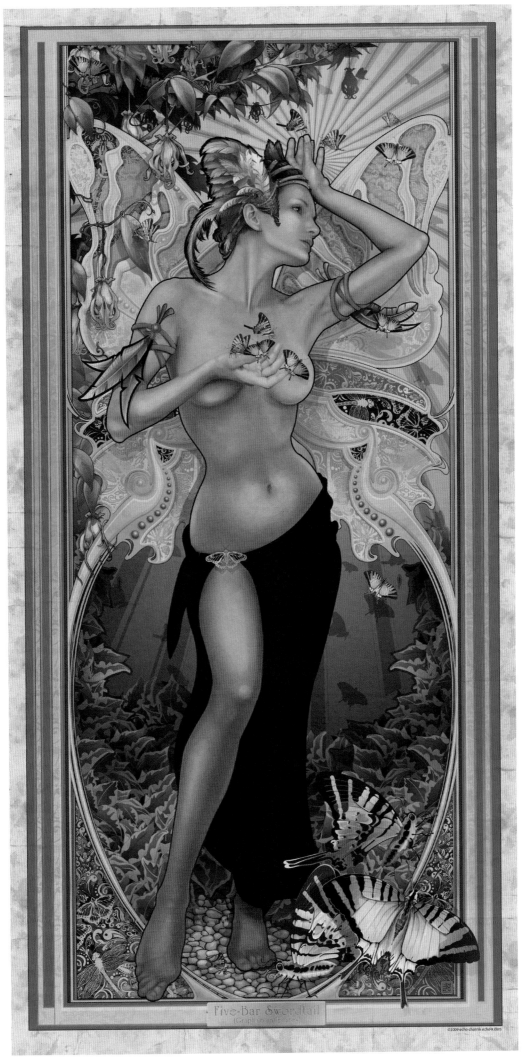

Five-Bar Swordtail
(Graphium antiphates)

©2009 echo-chatnik echo4x.cbns

Hannah Christenson

"I have been in love with Illustration for a very long time. My favorite thing about fantastic art in particular is the amount of silent and delicate story building information that is shown to the viewer but never spoken of. This background information uses careful direction and just a few hints to open entire worlds to be explored."

—*Hannah Christenson*

Brigham Young University-Idaho BFA

www.hannahchristenson.com

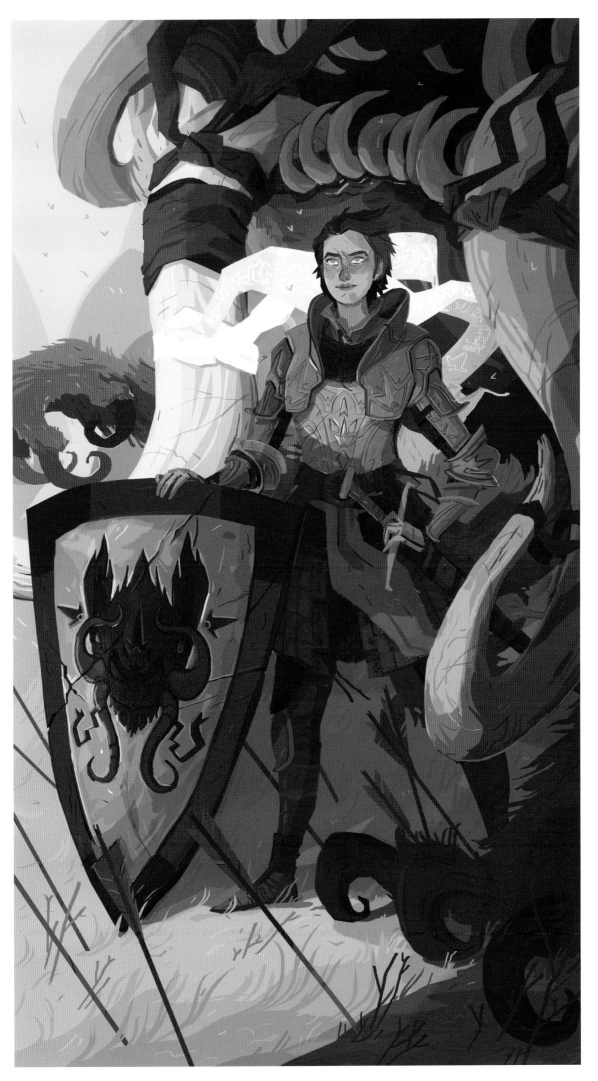

Photo by & copyright © Sabine Vollmer von Falken

Kinuko Y. Craft

"One of my earliest and fondest memories is of sunlight shining on a leaf suspended in a cobweb in a glassless window frame, moving to and fro in a soft breeze. There was a feeling of eternity in it, and at that time I thought it was the most beautiful thing I had ever seen. In a way, I have spent my life trying to capture the beauty of that moment in my art.

"My happiest time is when I stand in front of a white empty board: the space is full of hope. The images are already there, waiting for me to bring them to life. I can still dream that it will be the best work I have ever painted. I'm perpetually trying to paint and draw something that has the feeling of eternity, yet I always fall short. Trying to reach that goal is my ultimate and the only aim. Many things inspire me. It can be a beauty of the combination of colors, light of natural world, the work of another artist, myths, tales, folklore, poems or music that anything triggers my imagination.

"The wings which carry me to another world is my imagination—in other words fantasy, where something exists only if I wish to create it. It has to have all of my hope and dreams in it. In a way everything I have ever created is fantastic art. It's that process of bringing to life something that does not actually exist in the real world."

—Kinuko Y. Craft

Spectrum Grand Master/2002
Society of Illustrators Hall of Fame/2008
World Fantasy Award: Best Artist/2011
Book: *Kinuko Craft Drawings and Paintings* **[Imaginosis]**

www.kycraft.com

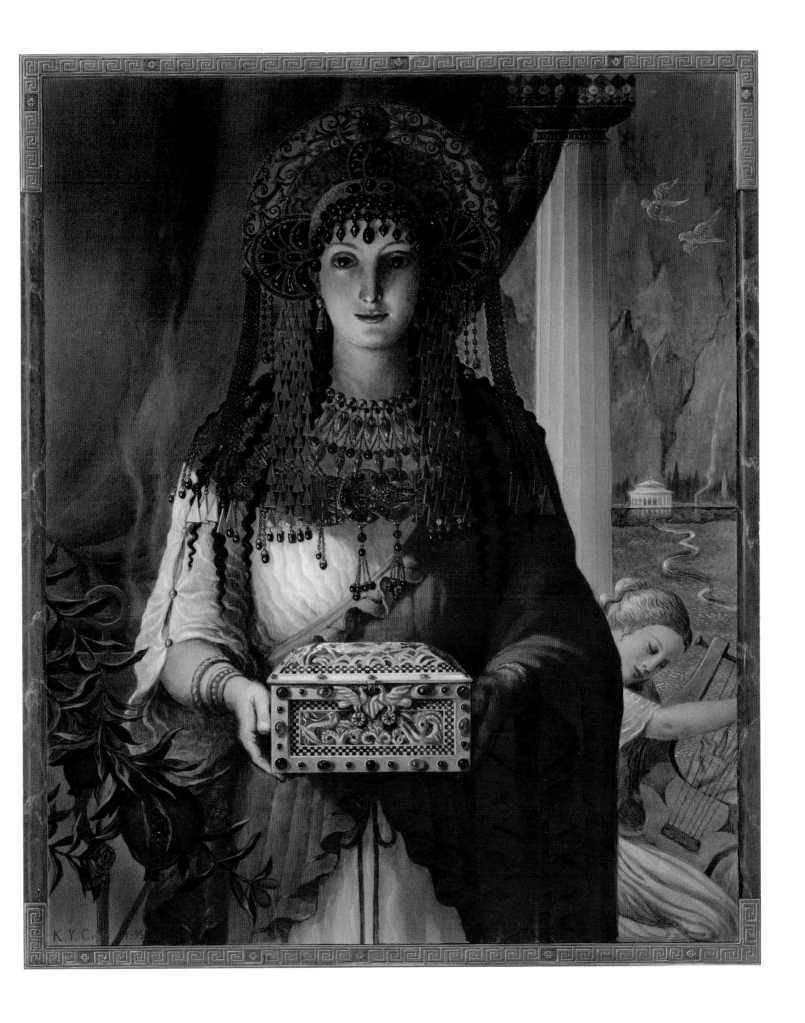

Photo by & copyright © Greg Preston/Spectrum Fantastic Art Live

Camilla d'Errico

"My work is emotive, edgy—and somewhat surreal and like a puzzle. I use bright colors to convey emotions and there is always a combination of emotions in each image; I have my own story to tell and each element of a painting has a specific meaning within the context of the entire piece—but I want the viewer to see their own story or emotions in the painting, so the pieces are also completely open to interpretation.

"I am not a fan of labels in general; I feel that labels put people in boxes. And as you can see from my artwork, it ranges far too much to be contained in one box.

"I'm inspired by just about everything! Photography, nature, literature and emotions are the things that give me the most inspiration and stimulation —I can just as easily be walking down the beautiful streets of Vancouver or people watching from a cafe and find something that leaves an impression. I'm very strongly influenced by manga and by a great story, by the characters in the story and the emotions they elicit. And yes, I admit it, I am influenced by love: I'm a hopeless romantic."

—*Camilla d'Errico*

Book: *Helmetgirls: The Art of Camilla d'Errico Volume 2* [**Dark Horse**]
Book: *Pop Manga: How to Draw the Coolest, Cutest Characters, Animals, Mascots, and More* [**Watson-Guptill**]

www.camilladerrico.com

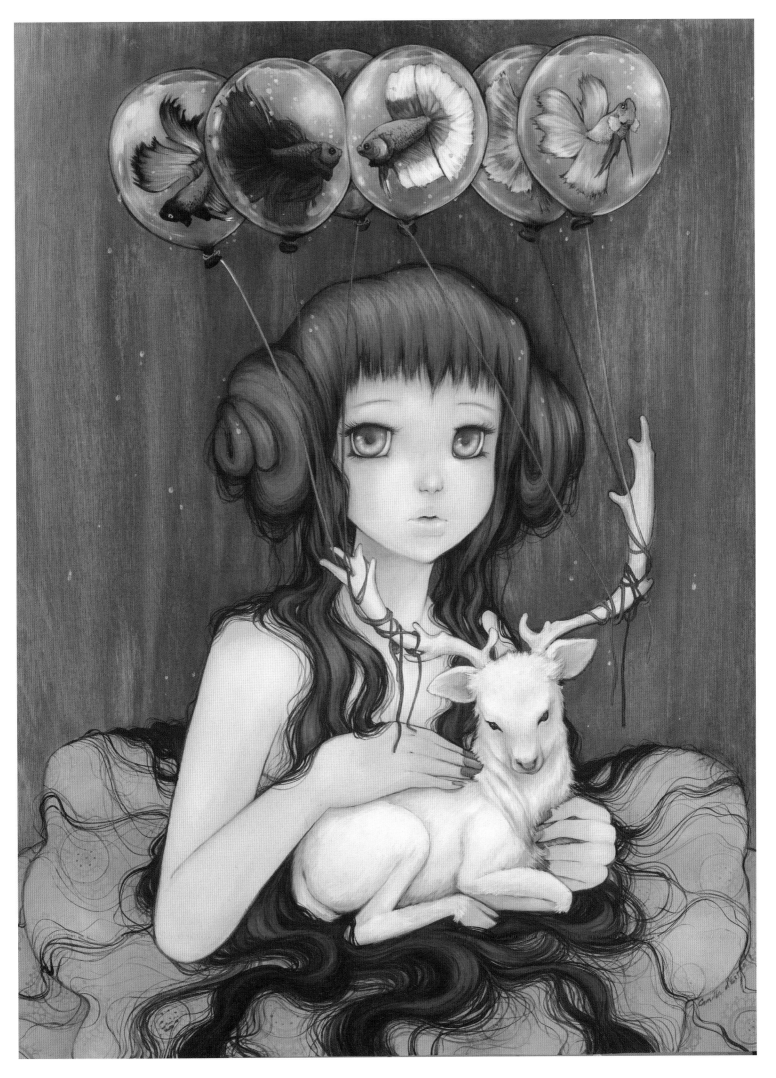

Mélanie Delon

"As far as I can remember I've always been attracted by fantasy stories or imagery, it was almost natural to me to explore that field in my work. Dreams and imagination are quite important in my life, it's my oxygen and a way to escape reality.

"I deeply love creating fantasy worlds and characters, and bringing to life unreal things is my main motivation.

"For me fantasy means freedom, I can mix symbolism with classical style and add some historical touches like architecture, or old patterns in a single composition. There is no limit to creativity, and everything is possible in Fantasy."

—*Mélanie Delon*

Book: *Opale: Requiem of the Night* [Exuvia]

www.melaniedelon.com
www.facebook.com/pages/Mélanie-Delon/205439922801734
melaniedelon.tumblr.com

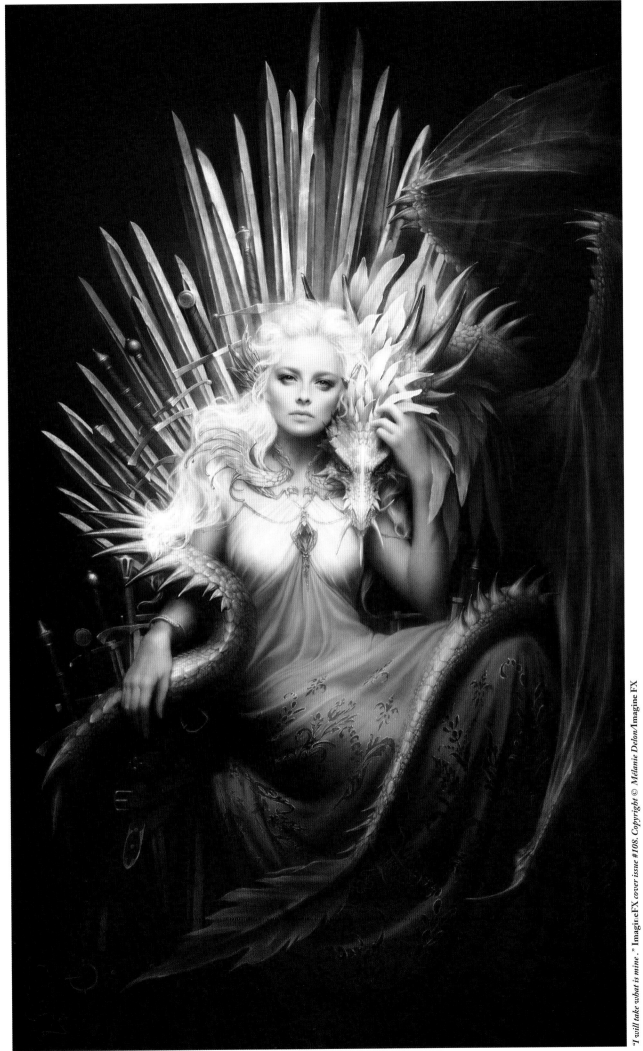

Zelda Devon

"I am Zelda Devon, a *New York Times* Bestselling illustrator from Brooklyn, New York. My work has a darkly whimsical edge that pervades everything from storyboards to concept art, advertising and typography. The focus centers on lush color-rich storytelling, enchanting and engaging the viewer. Costume design, architectural ornament, elaborate European fountains and deep sea giant isopods are some of my muses. I love dark, strange, twisted sad things. My influence casserole has many layers. I steal a little bit from everybody; it's harder to get caught that way."

—*Zelda Devon*

www.zeldadevon.com

Diane Dillon

"Although Leo and I began our career in advertising we are mainly known for our work in Science Fiction and Children's Picture Books. Both of these rely heavily on Fantasy.

"Fantasy begins in the mind before pencil touches paper, imagining worlds we have never been in. It frees us from the limitations and rules of reality but I believe the most successful fantasy must be believable no matter how unfamiliar the image may be. Our inspiration comes from familiar things around us that are used in an unexpected way. For example, a photo of a sea plant becomes a tree on an alien planet.

"[Regarding the painting opposite] Marie Laveau was a voodoo queen from New Orleans. She was a mysterious and magical figure described as very beautiful. Some say she used a snake in casting her spells. Not a lot is known about her life but many a myth has grown around her so we had the freedom to conjure up this image as we imagined her to be."

—*Diane Dillon*

Parsons School of Design graduate
Parsons School of Design Doctorate of Fine Art
Hugo Award for Best Professional Artist/1971
Caldecott Medal/1976
Caldecott Medal/1977
Spectrum Grand Master Award/1997
Illustrators Hall of Fame Inductee/1997
World Fantasy Convention Life Achievement Award/2008
Book: *The Art of Leo & Diane Dillon* **[Ballantine Books]**

www.fdginy.com

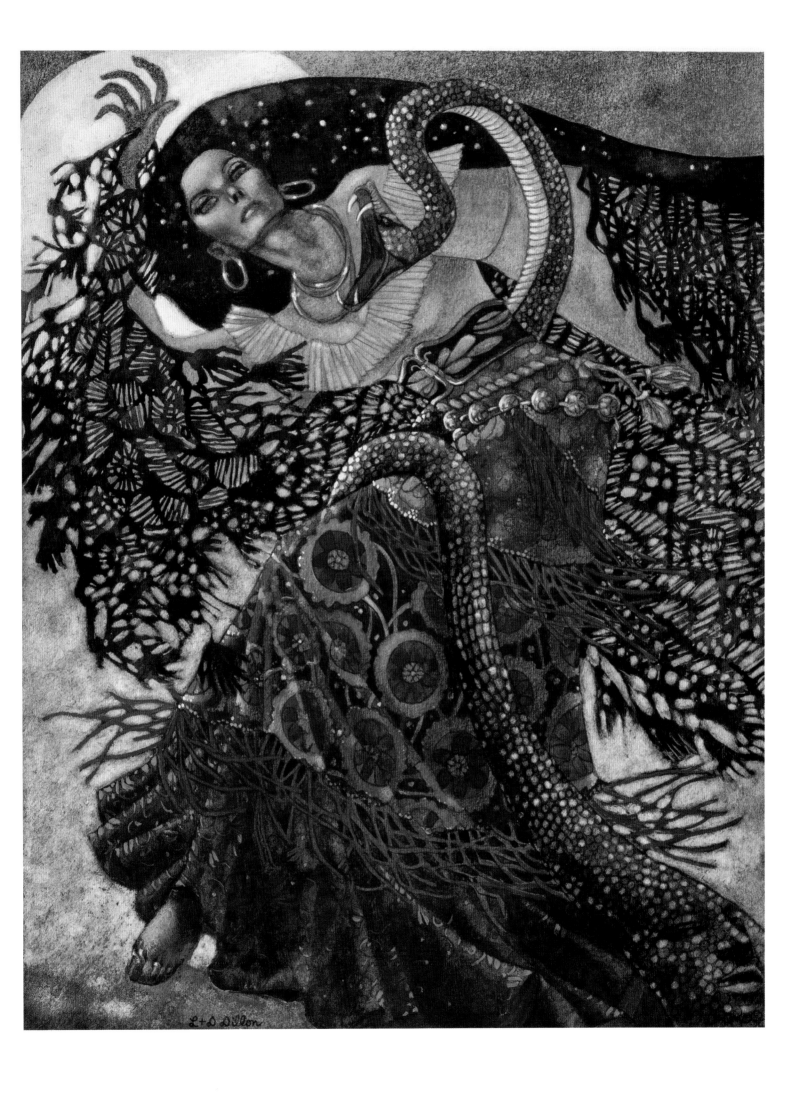

Julie Dillon

"Fantasy art gives me the freedom to really experiment and play with a wide variety of invented subject matter. It opens up new possibilities for storytelling and new ways to communicate ideas that I wouldn't have working strictly in fine art. The fantastical nature of the genre also allows me to take liberties with color, form, and composition that I might not otherwise have the opportunity to do."

—*Julie Dillon*

Sacramento State University BFA
Hugo Award for Best Professional Artist/2014
Book: *Imagined Realms Vol. 1*

www.juliedillonart.com

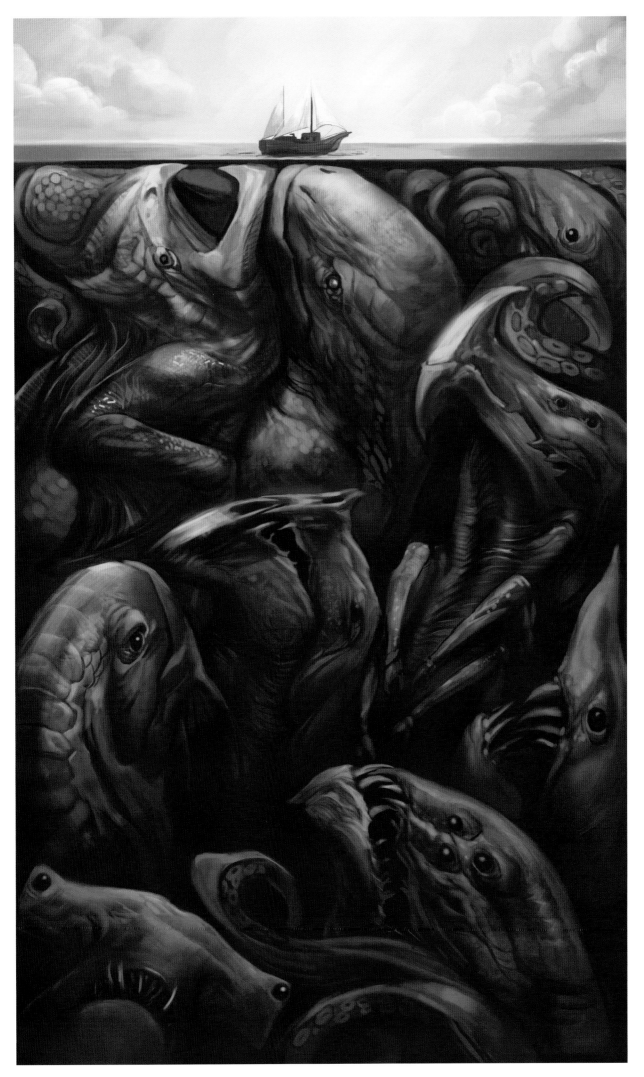

Photo by James Thoma

Lisa Falkenstern

"All my life I have been entranced by fantasy art. As a child, my earliest purchases were from an antique bookstore in New York City. It was a few tattered Beatrix Potter books and a book of fairy tales illustrated by Harry Clarke, missing most of its spine. That was the start. Instead of reading contemporary books, I poured though all the Andrew Lang books of fairy tales. As I got older, I collected books on all of the classic 19th illustrators, Arthur C. Rackham, Charles Robinson, Edmund Dulac among others.

"Is it the fascination of looking at things that do not exist? And yet, there they are. Rabbits wearing jackets and shoes, the Snow Queen on her sleigh, goblins and fairies drawn in precise India ink. In looking at all those images, we also get a peek into the mind of the artist who imagined them. As a lover of landscape painting I hate to say this, but anyone can draw a tree, just look outside. Fantasy artists look outside and see something else. They see trolls, Frazetta-esque warriors, and animals in all sorts of dress. And they make you see it also.

"Fantasy art, for me, delights the eye and intrigues the mind. To look at a piece of art, and get lost in its images and stories is a very pleasurable feeling. I am happy to be a tiny part of this tradition, which due to such a large and devoted following has no end in sight."

—*Lisa Falkenstern*

Parsons School of Design graduate
School of Visual Arts and Art Student's League

www.Lisafalkenstern.com
Facebook/Lisa Falkenstern Studio

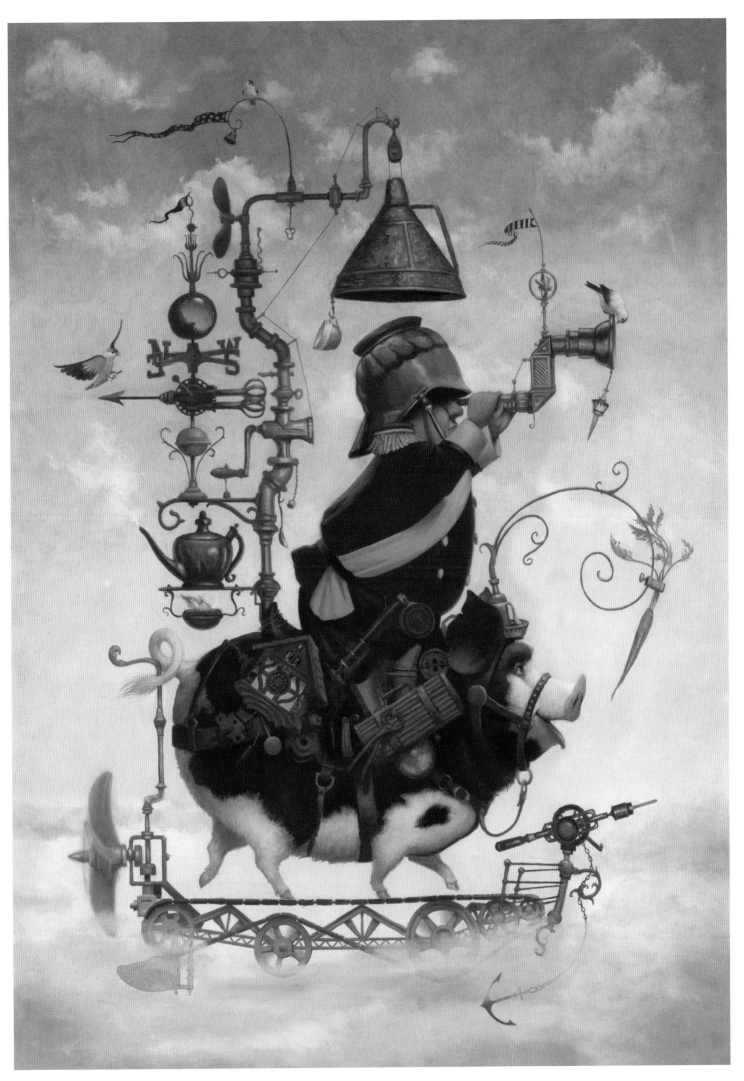

Anne Yvonne Gilbert

"When I was very small my mother would buy me old picture books from jumble sales, books illustrated by Rackham, Dulac and Heath-Robinson and from that point my love of myths, legends and the artists who depict them was born. I have some old drawings in primary school notebooks made when I was five years old and they show mermaids and princesses, knights on horseback and even St. George with the dragon proving that nothing much has changed over the years—I'm still drawing princesses and mermaids, knights in armor and dragons.

"For the last forty-plus years I have worked as an illustrator chiefly for publishers as illustrated books and the depicting of fantasies and legends remain my obsession. I still get deep satisfaction from the process of illustration, reading the manuscripts, imagining my characters and designing the spreads. I have always used friends and family as my models dressing them in old clothes and lengths of material, making them act out the part in front of the camera and I hope they all get a kick seeing themselves in their roles, be it Robin Hood or the Medusa.

"I was overjoyed to be commissioned by Templar Publishing to illustrate *Dracula*, a subject I had long wanted to tackle but had never been asked as, presumably, my artwork was considered more suitable for lighter fare! I immediately started on a series of explorations using different materials as Mike Jolley of Templar and I were interested in exploring new techniques. The piece shown here was my first realization; painted in acrylics to enable me to achieve deep, velvety blacks and a sensuous atmosphere it was eventually superseded by a technique that overlaid colored pencil with drawing ink which was both more graphic and contemporary. For more information on the *Dracula* project please visit my blog and website."

—Anne Yvonne Gilbert

gilbertandnanos@rogers.com
www.yvonnegilbert.com

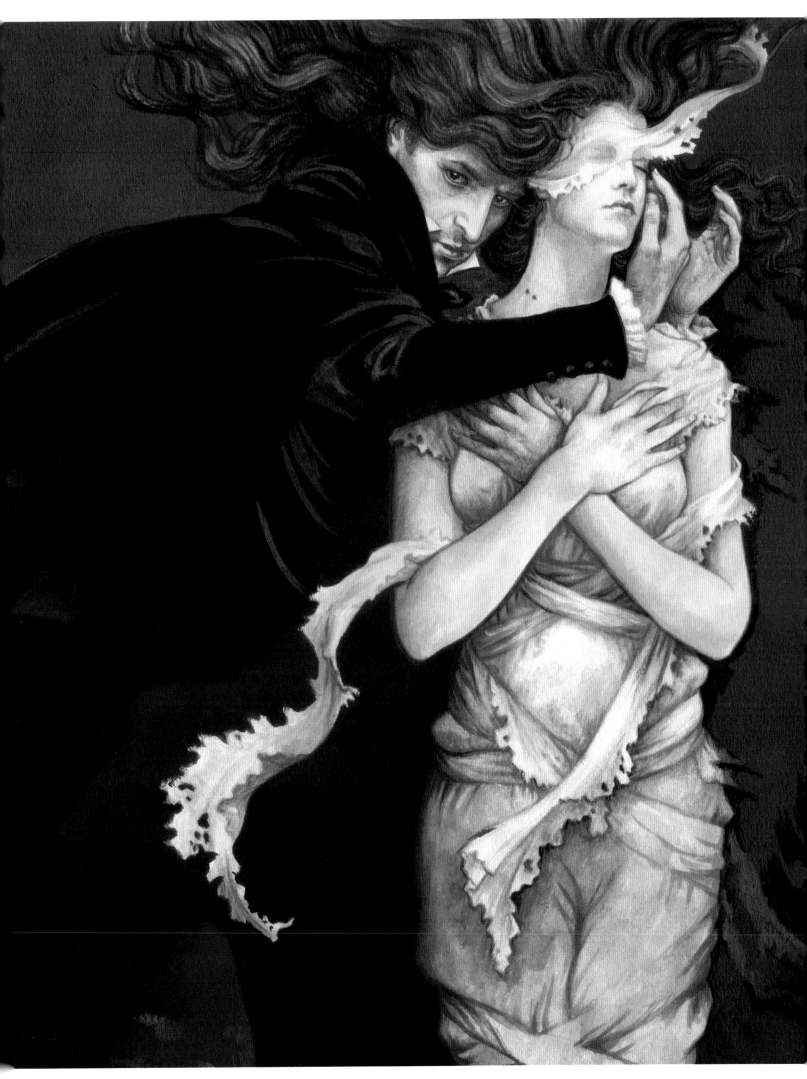

Rebecca Leveille-Guay

"Rebecca Guay's artwork shows a distinct influence from the great Renaissance masters, revamped with a fresh dosage of contemporary cleanliness and edge. Depicting the lush, effervescent world of nymphs, gods and goddesses, these [images] capture an otherworldly realm rife with a softened kind of carnality."

—Juxtapoz Magazine

Pratt Institute
Founder: Illustration Master Class and SmArt School
Book: *Evolution: The Art of Rebecca Guay 1993-2014*

www.rebeccaguay.com
www.rleveille.com

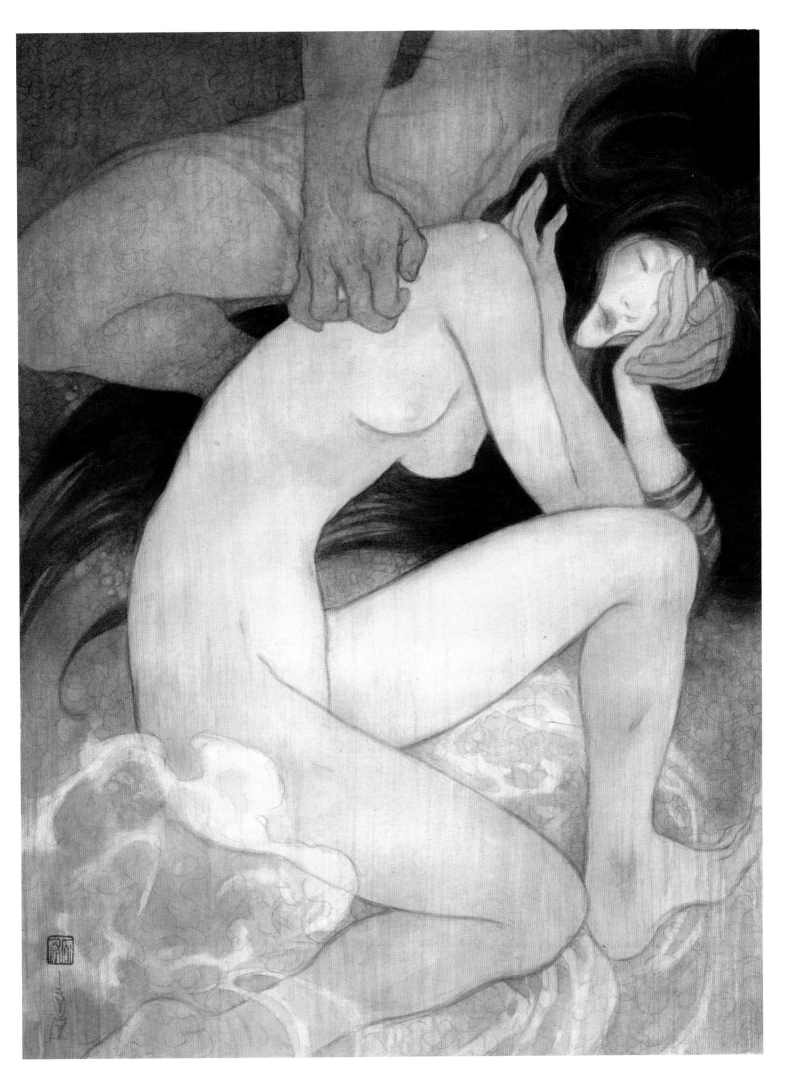

Christina Hess

Among walls of brilliant Forsythias and banks of lush Crown Vetch Christina spent her childhood drawing the many animals around her family's home in Lititz, Pennsylvania. When she wasn't painting or wrangling the wholly bears that dared make their way into her line of vision she would sneak into her mothers library. It was among those multicolored spines where she fell in love with book cover illustrations. Somewhere between the stacks of romance novels and James Herriot's tales she decided to pursue a career in illustration and shuffled off to Philadelphia.

There she studied at the University of the Arts where she was introduced to the power of caffeine and experimented with oils and tactile collage techniques. Soon after graduation she started painting digitally once a catastrophe befell her humble city dwelling. She soon realized that she could mix traditional mediums with digital successfully. It was then that she started to explore the incorporation of her childhood adventures into her work. Some of her work has been featured in *Spectrum: The Best in Contemporary Fantastic Art, ImagineFX, Expose, Exotique, 3x3 Magazine Pro Show, 3x3 Magazine Picture Book,* and the Society of Illustrators West.

She resides in South Philadelphia where she drinks copious amounts of coffee and attempts to grow green things. When not in her studio she teaches art to gaggles of college students. Currently she is writing, illustrating and designing her first book, *Animals From History.*

www.ChristinaHess.com
www.AnimalsFromHistory.com

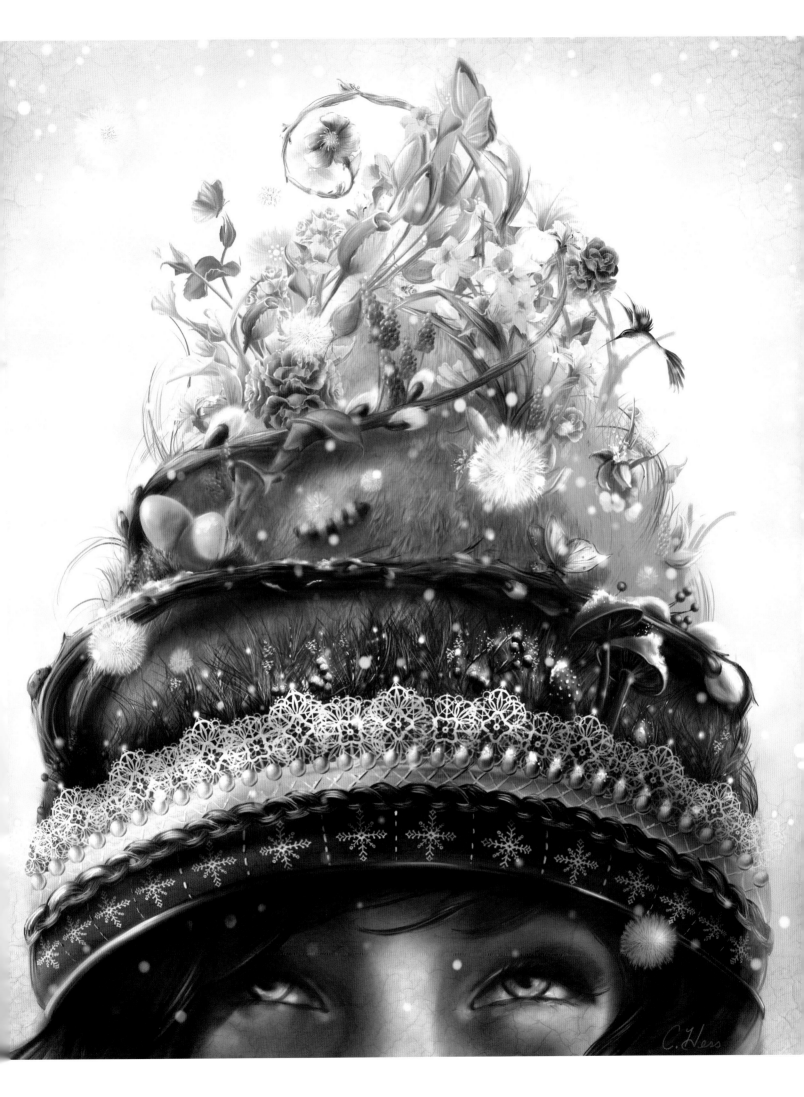

Kimberly Kincaid

"The poet Emily Dickinson wrote, 'I dwell in Possibility.' That's what I love about what I do and why fantasy art entices me. Anything that can be envisioned or imagined is possible. I love the challenge of visually expressing my personal voice when telling a story through illustration. It's the quieter, insightful moment of storytelling that lures me…the intake of breath, the pensive gaze, or the moment of wonder. I prefer to bring the viewer up close to the subject's face, using the subtle nuances of human expression to convey the intended emotion.

"Fairy tales and books have influenced me throughout my life, especially in the last decade. When I connect with a particular character from a book, envisioning what they might look like typically ignites the need to draw them. By "stepping into the illustration", the character's personality and intent are clarified, helping me to define what emotion I want to communicate to the viewer. This process requires me to trust my intuition and when someone connects with that drawing or painting, the experience is extremely rewarding.

"Maya Angelou has said, 'There is no greater agony than bearing an untold story inside you.' Artists are visual storytellers, using the language of image making to convey a narrative to its viewer. My stories have patiently waited their turn to be revealed and communicated since resuming my artistic journey after raising my family. Wonderful teachers have been put on my path to instruct, encourage and inspire me to depict these stories with emotional conviction and passion. I am so grateful to be given this time to realize my dreams of becoming an artist."

—*Kimberly Kincaid*

www.artbykimkincaid.com

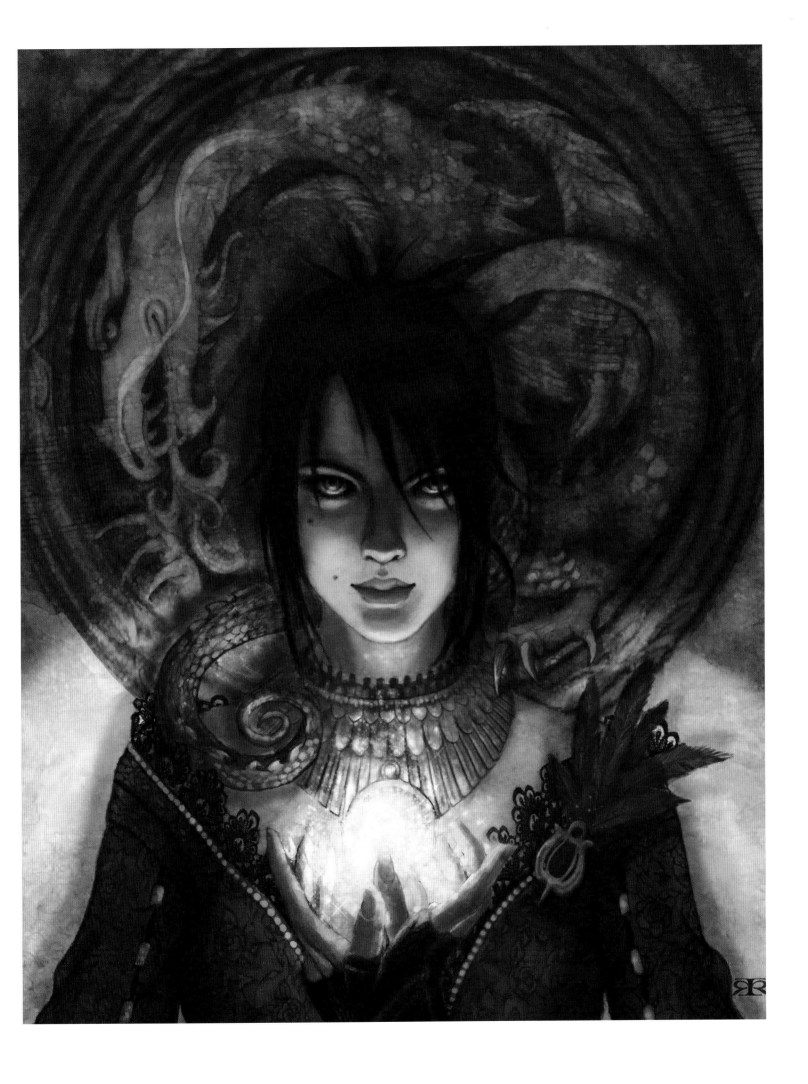

Andrea Kowch

"Searching for, discovering, and feeling the magic of nostalgia in the everyday is a major source of inspiration in my work. The fantastical, mysterious, mystical qualities I so often personally associate with nature and the past are qualities that drive my work. There is a sense of wonder and the supernatural that I find in things old and bygone, and such wonder leads me to fantasize and create the dreamlike scenarios that are my paintings.

"Inspired by memories, inner emotions, history, and my fascination with nature and the human psyche, the stories behind my paintings stem from life's emotions and experiences, resulting in narrative, allegorical imagery that illustrates the parallels between human experience and the mysteries of the natural world.

"The lonely, desolate American landscape encompassing the paintings' subjects serves as an exploration of nature's sacredness and a reflection of the human soul, symbolizing all things powerful, fragile, and eternal. These real, yet dreamlike, scenarios serve as metaphors for the human condition, all retaining a sense of vagueness because I wish to involve and motivate the viewer in uncovering the various layers of mood and meaning to form conclusions from their own perspective, despite that my main idea will always be before them.

"We all share a common thread, and as active participants in an ever-changing modern world, the purpose of my work is to remind viewers of these places that we sometimes perceive no longer exist, and to recognize and honor them as a part of our history that is worth preserving.

"In juxtaposing the human form with animals and a bygone uninhibited American landscape, I provide glimpses into "rooms," those oftentimes chaotic places we possess internally. The rural, Midwestern landscape of my home state serves as backdrop for the stage of human emotions. The animals present are vehicles for expressing the feelings and underlying tensions suppressed behind the human mask. Symbolic explorations of the soul and events concerning our environment are expressed through the combination of these elements to transform personal ideas into universal metaphors.

"Through my characters and the settings and environments in which they dwell, my intention is to tell stories and invite viewers to take part in and contribute to these stories in their own personal, unique way. Fantastical art opens up our imaginations, allowing us to escape from the commonplace, and enter into the free worlds of our own making, reconnecting us with the truest, deepest depths of our dreams, emotions, and souls."

—*Andrea Kowch*

www.andreakowch.com
www.facebook.com/andrea.kowch.artist
www.twitter.com/andreakowch

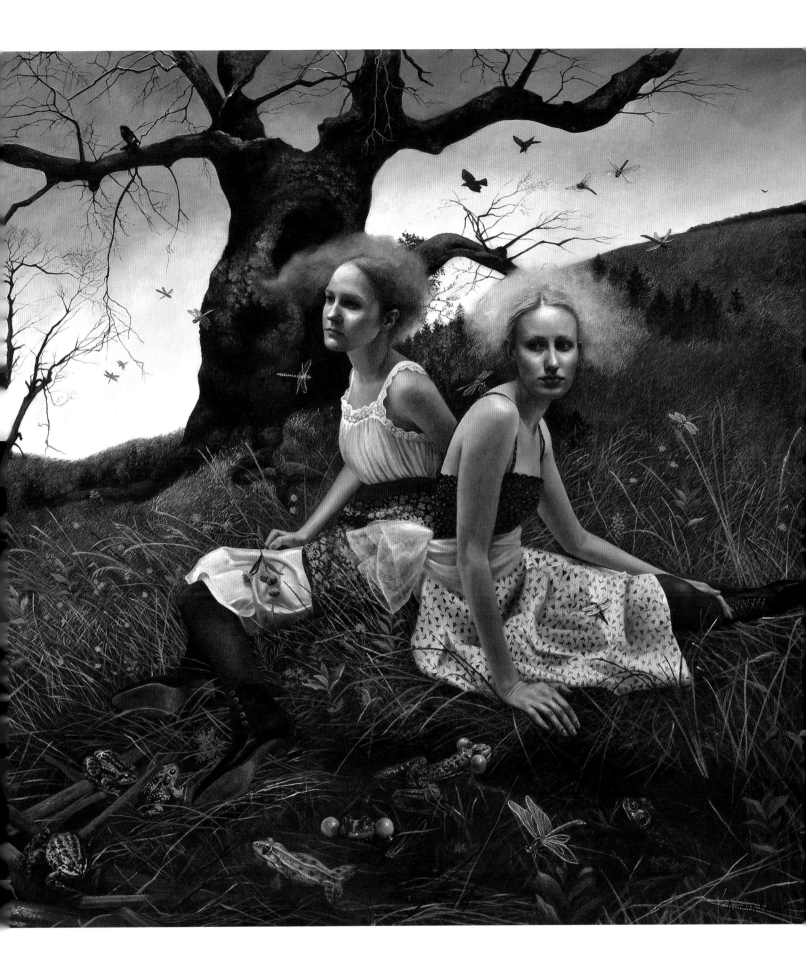

Anita Kunz

"My art has, for three decades, been concerned mainly with social and political issues and has been widely shown in print and galleries. My illustration work has been published internationally in magazines and books.

"The Madonna image [opposite] was in a series of celebrity portraits I produced mainly for magazines, including *Rolling Stone*, *Time*, and *The New York Times*.

"I've been made Officer of the Order of Canada, my country's highest civilian honor, and more recently I received the Queen's Diamond Jubilee Medal of Honour for my work."

—*Anita Kunz*

The Ontario College of Art and Design University graduate
The Ontario College of Art and Design University Honorary Doctorate/2010
Les Usherwood Lifetime Achievement Award/1997
Designated as one of the fifty most influential women in Canada by the *National Post* newspaper

www.anitakunz.com

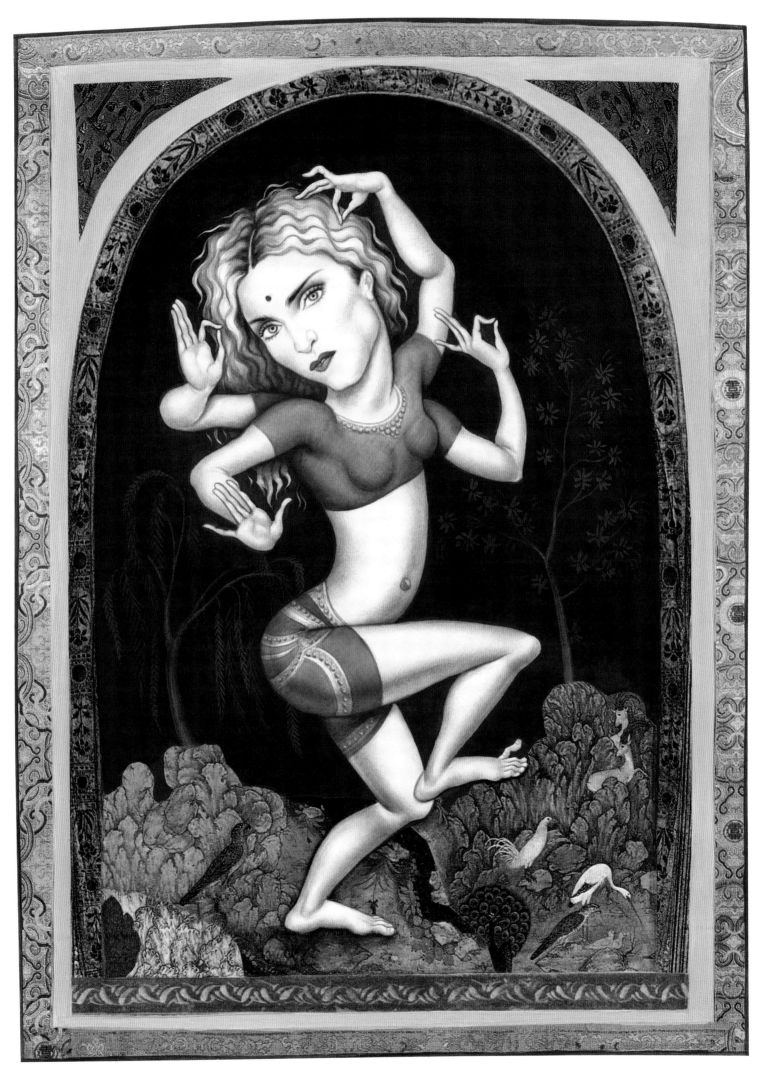

Jody A. Lee

"As a child I spent many pleasant hours reading the Lang Fairy Books and fairy tales and legends from other lands. I am sure that is where I began my long fascination with fantasy art and it's themes. I think my work is inspired by the same sensibility of latter Pre-Raphaelites like William Morris and Edward Burne Jones, which makes some sense since the Fairy books were illustrated by their contemporaries. I want my paintings to have that same wistful, dream-like longing for a mysterious, magical otherworld. But since most of my work was and is done for publishing, I generally tailor my tastes to match the story I'm illustrating. I like having an author's parameters and input, to be given ideas and images to create from outside my own perspective.

"Even though I have been working as an artist for the last 30 years, I still find myself feeling like a novice, that there are fresh areas to discover and explore, that there more things to learn. I also know that this insecurity is just an old acquaintance to push out the door when work is to be done. My favorite art teacher, Barbara Bradley of the Academy of Art University (I'm in the Class of 1980), used to tell to her students, that we were always seeing the negative in the work we were doing, while she always looked for the positive first. It is easier to see the positive now. What I find is that maturity does bring a little more certainty as to what I like, and to the direction I want to go in, however doubtful I might be of my ability to carry it out. Just keep on working!"

—*Jody A. Lee*

Academy of Art University graduate

www.jodyalee.blogspot.com

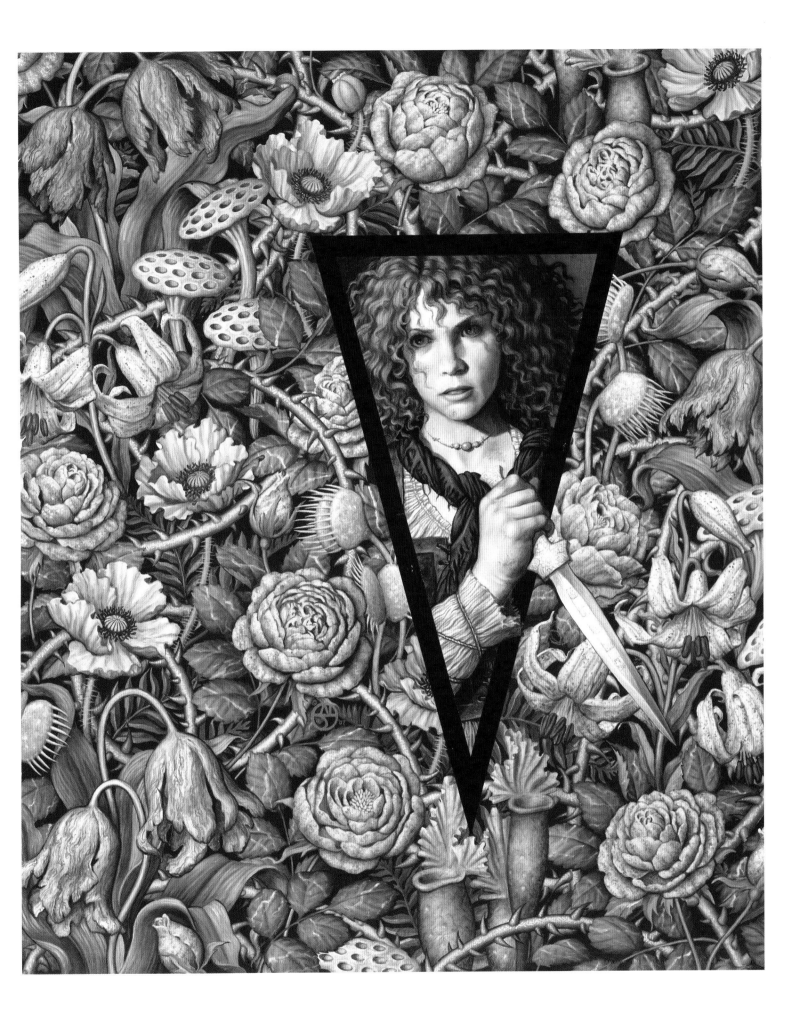

Sacha Lees

"The scope for artistic freedom is endless for the fantastic artisan and this is what truly excites me most about creating in this genre. Fantastic art challenges the viewer to enter worlds unknown with new rules and possibilities. It is not bound by its own history and like the English language it has the ability to merge any style and evolve in its own unique direction.

"As a child I naturally gravitated to the surrealist artists, especially Salvador Dali and Magritte. I felt a connection with these artists in this movement—their energy, their freedom to express who they truly were—that helped me make sense of my world and the way I perceived it.

"Inspiration for me is present always—an uplifting or ominous skyscape, the colors in the glint of light, the passion that exudes from someone who loves what they do. The battle I find is relaxing into the pool of my mind and letting the evolved ideas bubble to the surface.

"I wish to create a feeling of wonder—uplifting the spirit of the observer when they view my work.

"My creative process involves listening to music to help connect me with emotions I aim to explore in my paintings. Music in the minor key for me is especially moving. It enables me to connect at a deeper level.

"I find my storytelling works through subliminal channels. If I don't over analyze the message then the artwork speaks its own truth to the observer.

"Like probably all artists my long term goal is to strive to get closer to the light—in purity of message, effortless technique and in true mind escapism."

—*Sacha Lees*

www.sachalees.com

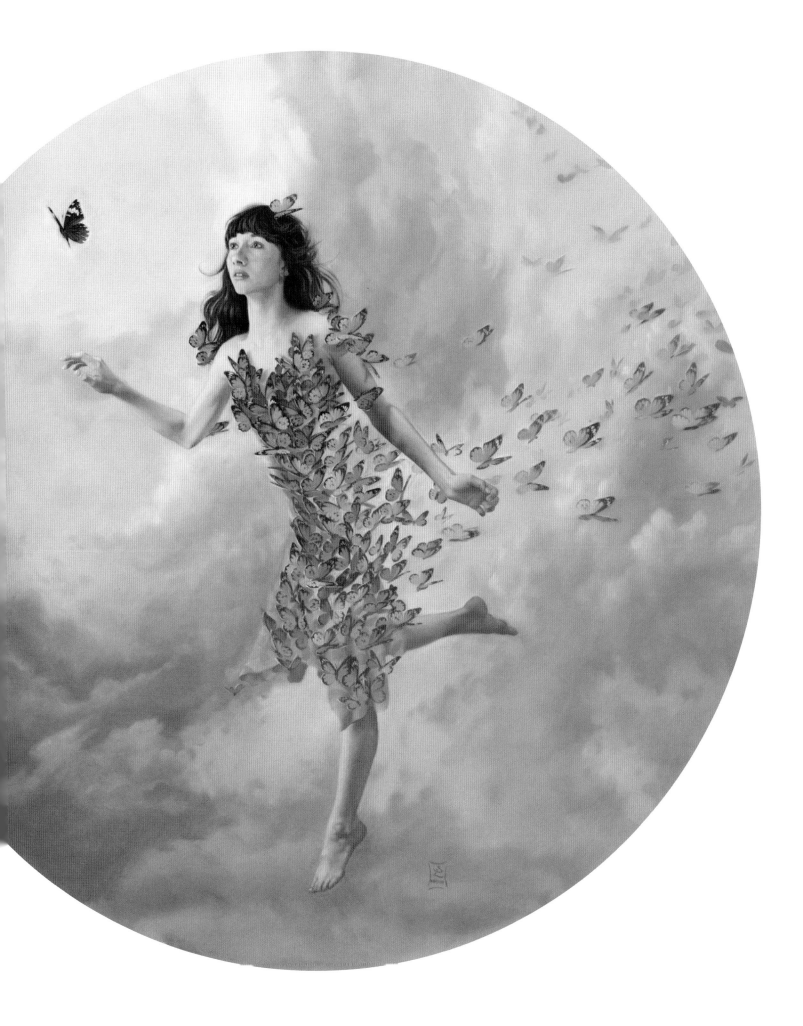

Vanessa Lemen

"One of the really amazing things about art, in many respects, is that it starts with the artist simply making a mark, and once finished, has the potential to make quite a mark on its own for the rest of its existence and even beyond that. In the beginning, the mark-making is a form of dialogue between the artist and the canvas. It's a back-and-forth, a reciprocity. Then, the dialogue gets passed along in the form of the painting itself, and becomes a continuation of that dialogue to other human beings as an extension of the conversation. By viewing the painting, others may be moved to communicate, listen, think, or just get something from it that they can hold onto and take with them – maybe something they couldn't quite put into words – and that may be one of the biggest motivations for us to keep scratching at the surface. The paintings we make can invite someone in to experience that intangible place, where it's as vast and real and amazing as it gets—a place that words cannot truly define. And by way of the painting, no matter what the location or time frame may be, we can actually go there and connect for a bit. And that's pretty awesome."

—*Vanessa Lemen*

San Diego State University graduate

www.VanessaLemenArt.com

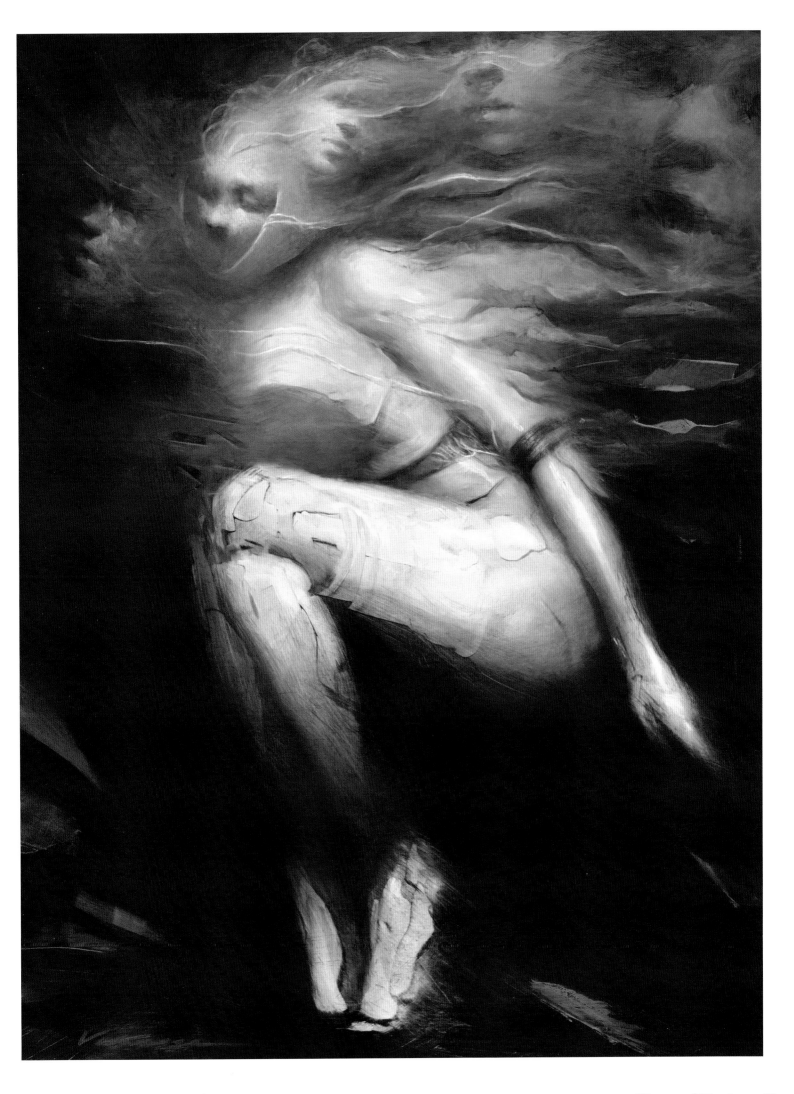

Lindsey Look

"Through most of my childhood you could find me adventuring around the woods behind my house, drawing mermaids and fairies, or curled up next to one of my parents as they read aloud everything from Roald Dahl, C.S. Lewis, and Philip Pullman. Since there was always a paintbrush or a pencil in my hand, there was never much question as to what I was going to do with my life when I became an adult. Painting and drawing the fantasy stories I grew up with was as much a part of me as breathing was. It was this early exposure to fantasy stories that profoundly shaped who I am today. I get immense satisfaction from being able to visually depict the same sense of escapism that one can get from reading.

"I attended The Art Institute of Boston with the intent to major in animation, but realized that I loved designing characters and their environments much more than the repetitive sketching that animation required. So I put all of my time and effort into the illustration department at AIB, and graduated magna cum-laude with a BFA in Illustration.

"Currently, I spend most of my time painting fantasy book covers and images for card games. All of my work is painted traditionally in oils on gessoed illustration board. My work has appeared in multiple volumes of *Spectrum: The Best in Fantastic Contemporary Art*, and some of my clients include Wizards of the Coast, Penguin Books, Audible.com, Applibot, and Science Fiction Book Club."

—*Lindsey Look*

The Art Institute of Boston BFA Magna Cum-Laude

www.LindseyLook.com

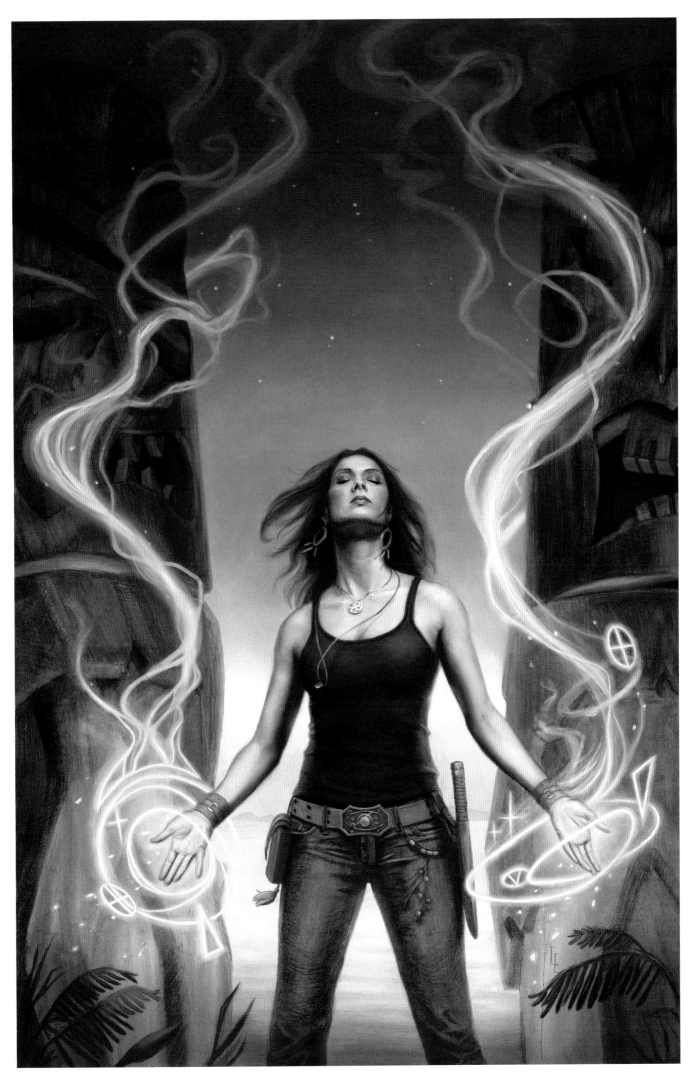

Alexandra Manukyan

"The central theme that unites all my paintings examines how seemingly separate and isolated life experiences actually disguise the extent of our individual and communal bonds. The 'masks' and the accompanying identities we all assume depending on the life role we must play, obstructs the conscious mind from acknowledging what truly unites us through the isolation and chaos: our shared encounters of pain, loss, desire, and longing for serenity and acceptance. The false facades we all manufacture to adapt and belong also render most blind and lost in a world where the meaningless has somehow become meaningful and the idea of a shared honest self devoid of hidden agendas all too infrequent.

"I focus on combining traditional oil painting techniques with surrealist symbolism to explore the presumably dystopian landscape of emotional and physical scars carried all too often amongst the female characters. However, the subject of my paintings refuses to fall into victimhood or self-loathing; instead, the women that often preoccupy my paintings figuratively and literally wear their wounds with resounding pride and empowerment. The mistakes of their pasts, the festering wounds of pain and loss, and the hauntingly icy stabs of betrayal, none of these specters weigh them down or define their destinies."

—Alexandra Manukyan

www.alexandramanukyan.com

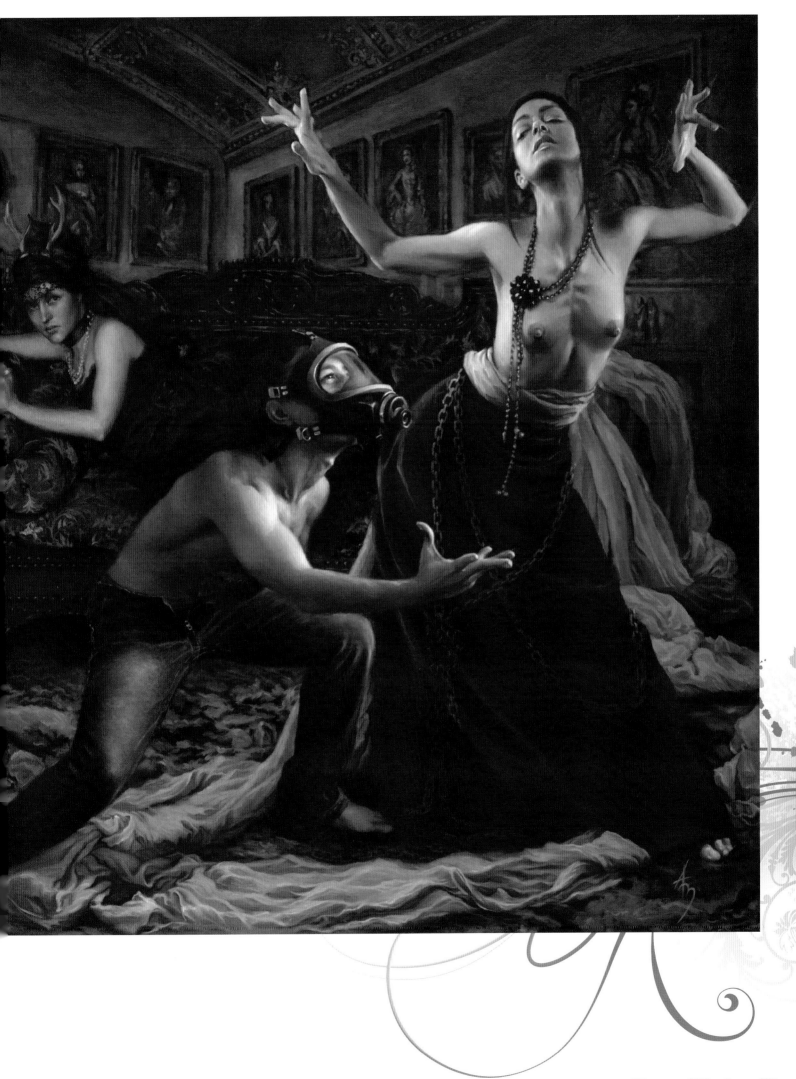

Carly Mazur

Connecticut illustrator Carly Janine Mazur works traditionally to bring to life her vision of a solitary world. Her paintings evoke a sense of intimacy within the viewer, inviting you in with solid composition juxtaposed against fine rendering. Carly's subject matter focuses on the hauntingly rendered human figure within a minimalistic, yet harsh environment to touch upon peoples' reclusive relationship with their environment.

www.carlyjanine.com
carlymazur.blogspot.com

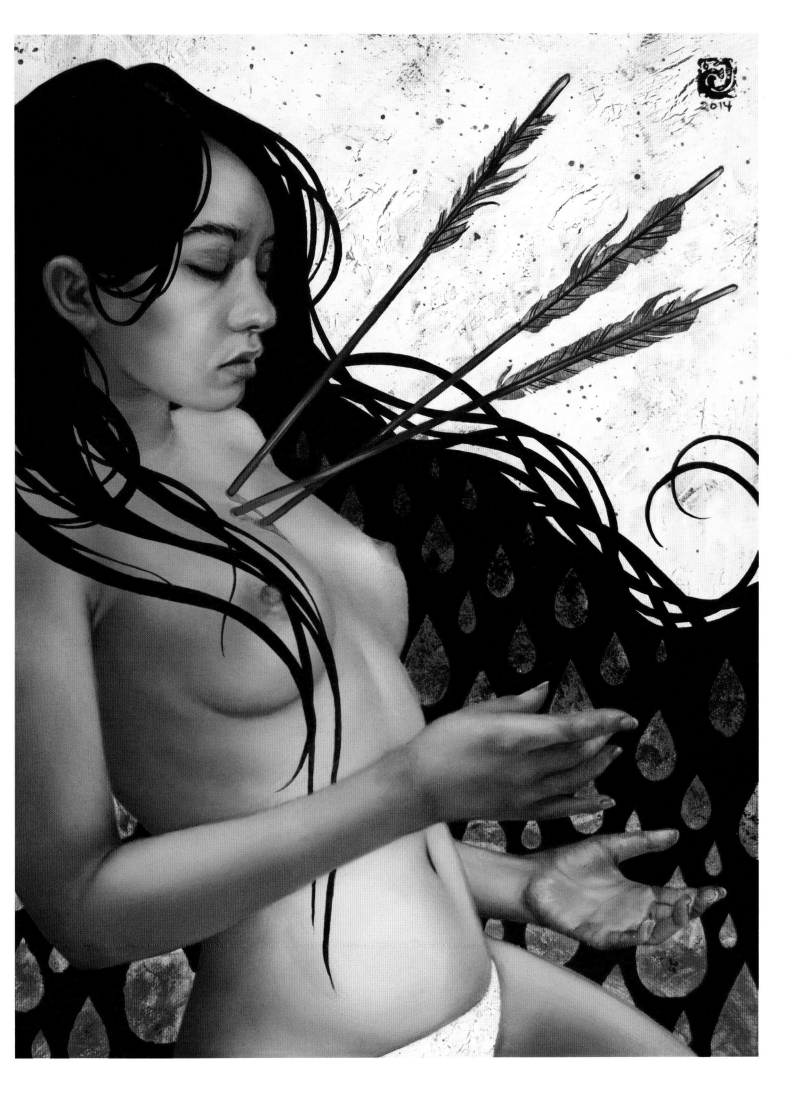

Tara McPherson

"I want my art to be subtly unnerving. Even if it's cute and innocent and sweet, I want it to be a little unsettling. I think life is that way and I try to make my art a reflection on the complexities of the situations life puts you in.

"When I was in art school, I saw so many students get into style immediately, but I felt lost because I didn't force a style. I didn't know what to do. I was scattered. But by the time I knew what I wanted to do, I had built up my own visual vocabulary. Now I don't even have to think about it. If I have to illustrate something, it just pops into my head how it should look. Now it just happens naturally; it's second nature."

—*Tara McPherson*

Art Center in Pasadena BFA
Book: *Bunny in the Moon: The Art of Tara McPherson Volume 3* **[Dark Horse]**

www.taramcpherson.com
www.thecottoncandymachine.com

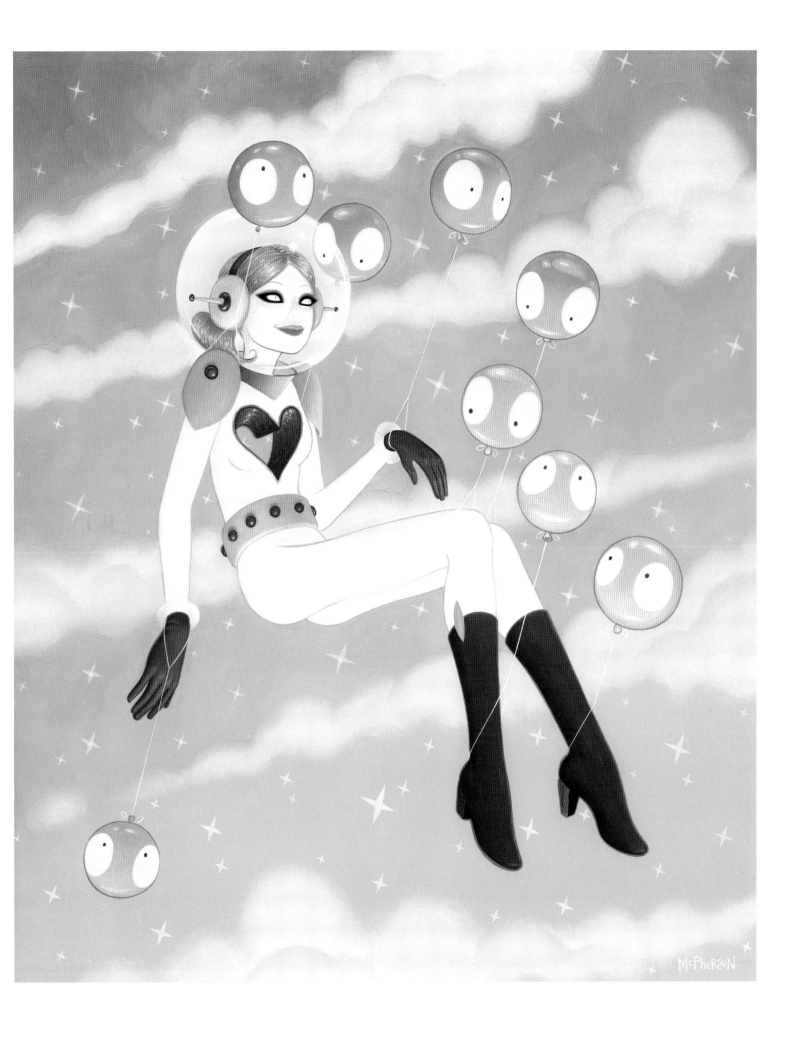

Ilene Meyer 1939-2009

"I start out painting just a picture, but as it progresses it becomes a new world: my imagination takes over and it starts to live and breathe on its own. I must calculate: If *I* were in that picture, what would I feel and, most important, could I really walk the path I have created? The creation takes over from there."

—*Ilene Meyer*

Harlan Ellison discovered Ilene in the art show of a Seattle science fiction convention and immediately commissioned her to paint the cover for his collection, *Harlan Ellison's Watching* (seen on the facing page). As a self-taught weekend painter she never planned to pursue an art career, but that assignment led to her first professional work from Underwood Books for whom she produced multiple covers for a series of Philip K. Dick collections. The exposure prompted multiple gallery shows, television appearances, and a documentary in Japan. A collection of her art, *Ilene Meyer: Paintings, Drawings, Perceptions*, was published by Underwood Books in 2004.

www.underwoodbooks.com

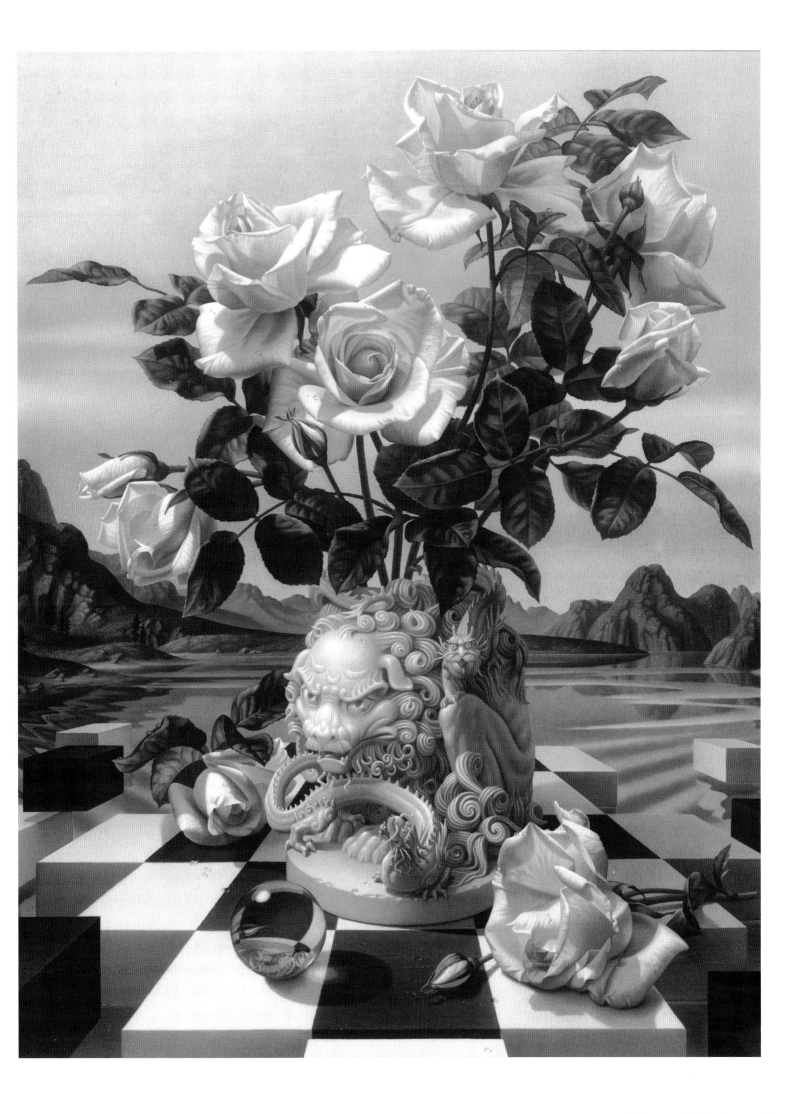

Brandi Milne

"Art is my first love. As far back as I can remember it was always my dream to be an artist. Something about using lines, forms, color and emotion to convey a feeling and/or story makes my brain tingle with excitement—and it always has. I'm truly thankful to be able to create in this lifetime, and for those creations to be supported and celebrated is fantastically humbling."

—*Brandi Milne*

Book: *Fröh Lich* [Baby Tattoo]

www.brandimilne.blogspot.com
Instagram: @brandimilne
Twitter: @brandimilne

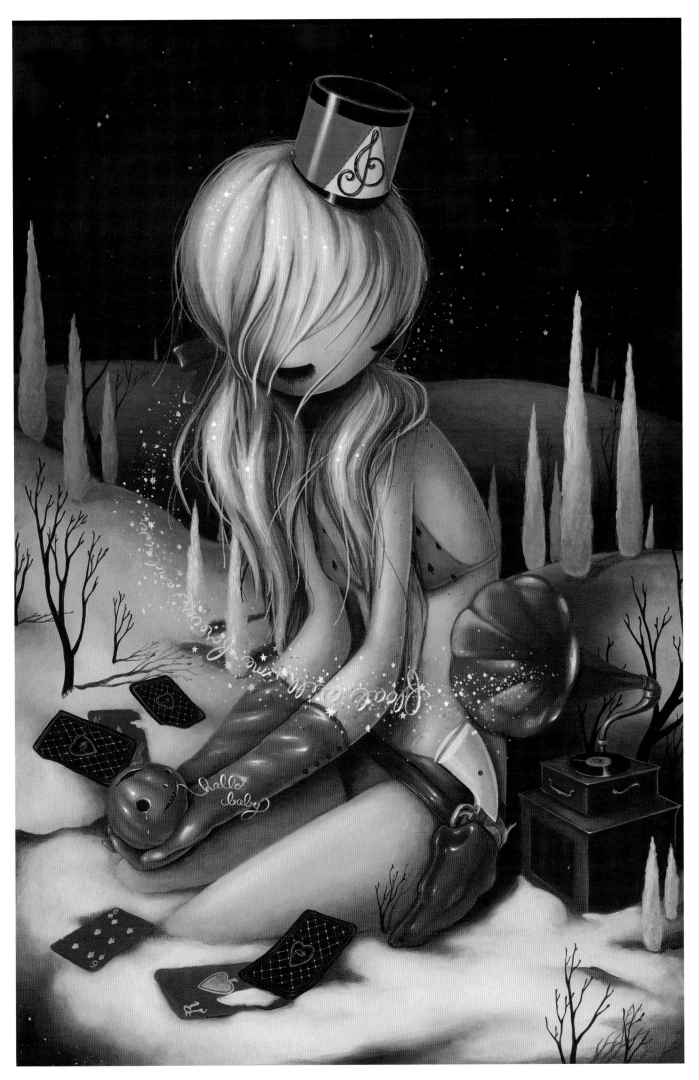

Sho Murase

Humans need fantasy to *be* human. To be the place where the falling angel meets the rising ape.

—*The Hogfather* by Terry Pratchett

"Why I love fantasy art."

—*Sho Murase*

www.facebook.com/Shomurase
www.shou-shou.com
shomurase.com/
Twitter @sho_moo
Instagram shomoo

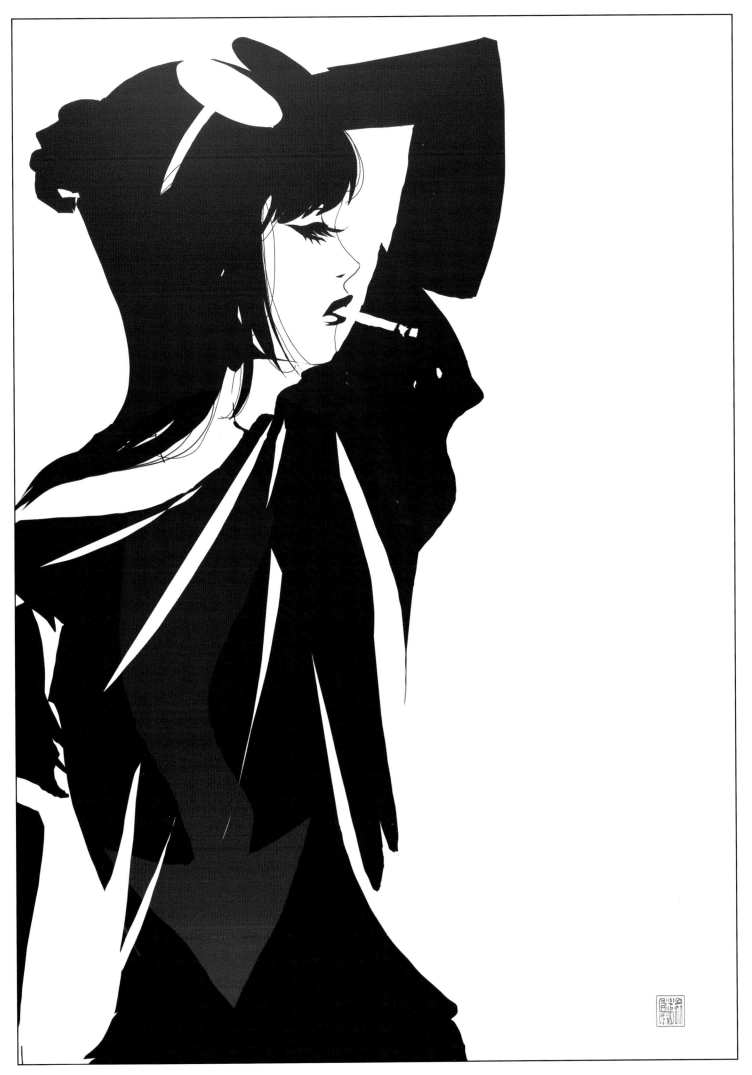

Winona Nelson

Winona Nelson was born in 1983 on the shore of Lake Superior. She grew up hearing traditional stories of her Native American tribe, the Ojibwe, alongside the more widely known fairy tales, myths, legends, and newer superhero stories, fantasy and science fiction books, and video games. Thoroughly surrounded by tales of supernatural powers and magic, but feeling left out of most of the stories she loved because she was a girl and wasn't white, she set out to bring more diversity to art for those who would grow up after her. She has since worked as a comics artist, a concept artist for video games, an illustrator for science fiction and fantasy book covers and trading card games, and a painter of fine art.

In her work, she reaches for worlds bigger and more dramatic and exciting than our own, where characters from all walks of life wield fantastical powers. She strives to capture her childhood feelings of wonder and adventure outdoors in Ojibwe land, where manitou or the Great Mystery unites all creation with a powerful life force—the feeling that you are much more than just yourself.

www.winonanelsonart.com
www.facebook.com/winona.nelson.art

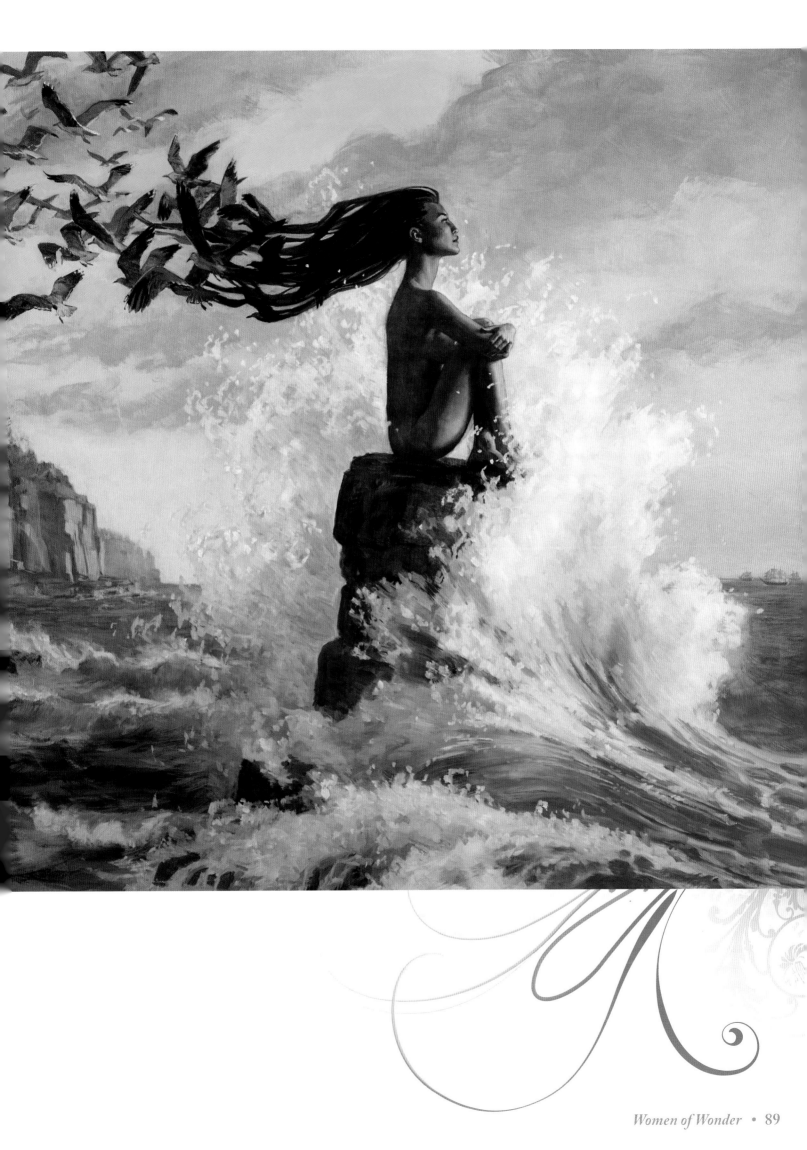

Victo Ngai

Forbes 30 Under (Art and Style) honoree and Society of Illustrators NY Gold Medalist Victo Ngai is a NY based illustrator from Hong Kong, graduated from Rhode Island School of Design. "Victo" is not a boy nor a typo, but a nickname derived from Victoria—a leftover from the British colonization.

Victo creates art for newspaper and magazines such as the *New York Times* and the *New Yorker*; makes books for publishers such as the Folio Society, Abrams and Tor Forge; and works on advertisement campaigns with companies like the McDonald's, IMAX, MTA Art for Transit (New York subway), Lufthansa Airline and General Electric.

Apart from drawing, Victo's biggest passions are traveling and eating. She's hoping that one day she will save up enough to travel around the world and sample all kinds of cuisine.

www.victo-ngai.com

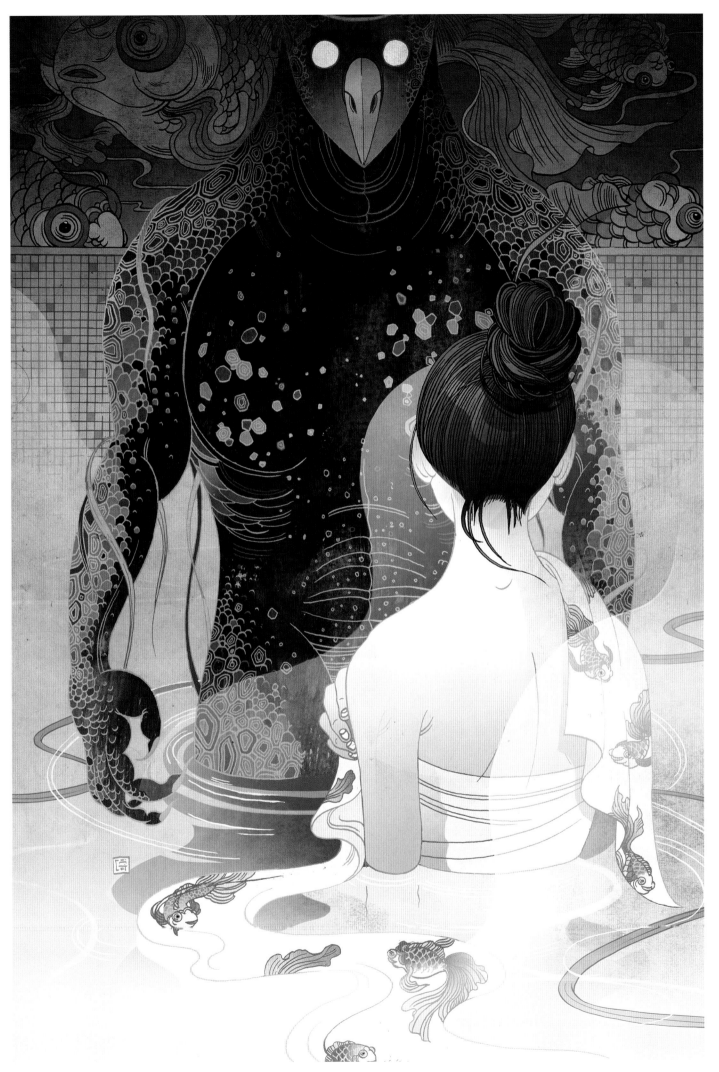

Photo by & copyright © Jo McCune

Tran Nguyen

Tran Nguyen is a Vietnam born, Georgia based artist who mobilizes her illustrative imagery as a vehicle for latent psychic experience. As haunting dreamscapes, the narratives that emerge from Nguyen's works are at once uncanny and eerily relatable. Suspended somewhere between waking consciousness and the subconscious, the imagery she unfolds feels as spontaneous and creative as the wanderings of free cognitive association. The stories that emerge from her pieces are charged with familiar psychological themes, everything from the phobic object, to the transformative metamorphosis, to the personal fantasy, but in the artist's hands, far from being contrived, these stories feel organic, immediate, and beautifully eruptive, as though they have unfolded effortlessly. It is this illusion of effortlessness that makes the work feel truly liminal. Looking into these images we are elsewhere, we are other, we are held by an ambiguous suspension of reality. At times the artist's strategies feel dark and haunted, but the beauty and delicacy with which they are rendered attenuates any feelings of anxiety or distress in their presence. This combination of charged content with delicate and luxurious execution make Nguyen's vision truly magnetic.

Tran Nguyen's pieces are deliberately and delicately rendered with subtle washes of diluted acrylic, and detailed applications of colored pencil. Her aesthetic and rendering convey affectively charged psychological landscapes, dreamy, sensual, surreal, and fantastic, like the hyper-real of the "elsewhere" in the truly immersive dream. The juxtapositions in Nguyen's work are fascinating. Unlikely pairings, and unexpected contexts emerge with seductive clarity. We are left with the feeling that nothing is extraneous, and that everything is connected to some ultimate symbology within the work. In the tradition of truly consummate illustration, each symbol, each suggestion of imagery, each object, is part of the narrative "moment", and everything has its place. The artist's interest in imagery as a vehicle for healing, combined with her masterful rendering of textures, skin, shadows and folds, speaks to the work's deeply psychological valence. From the recesses of the unresolved, emerge beautiful lush images; like exorcisms through imagery. While the work is evasive in its symbolism, something raw and relatable draws the viewer into the experience. The work luxuriates in the baroque excesses of the dream.

—*Marieke Treilhard*

www.mynameistran.com

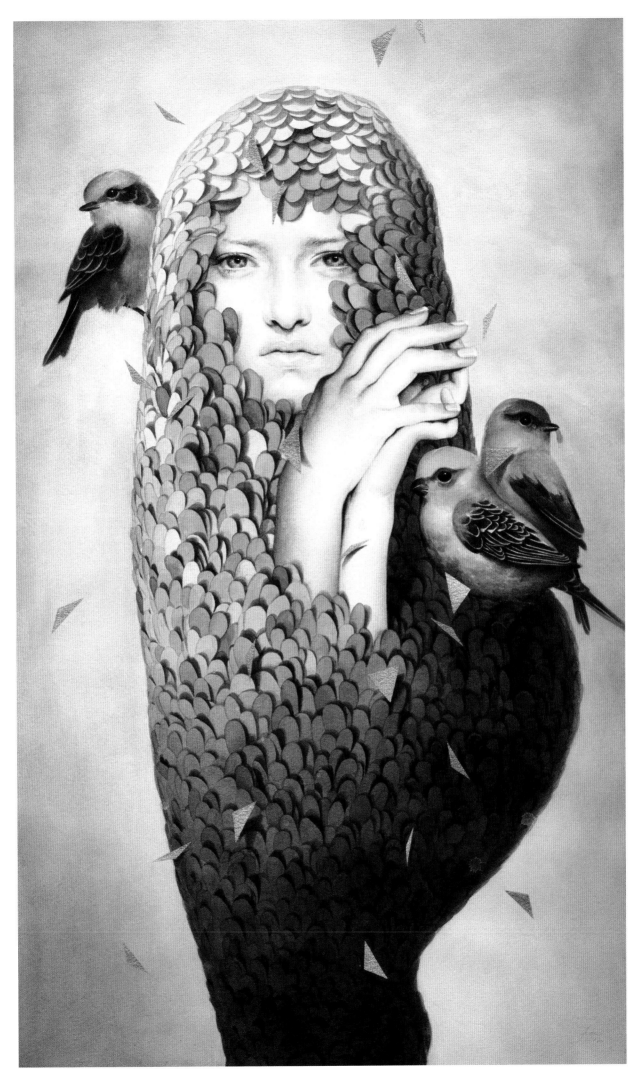

Terese Nielsen

"We act as midwives, birthing visions that camera can never capture, an amalgam of nightmare, hope and reality, boundless and illusory, like embracing a cloud or touching the tail of a fish… they come like dreams in the night, powerful yet elusive, leaving an inimitable mark across the soul."

—Terese Nielsen

Art Center College of Design graduate with Great Distinction

www.tnielsen.com

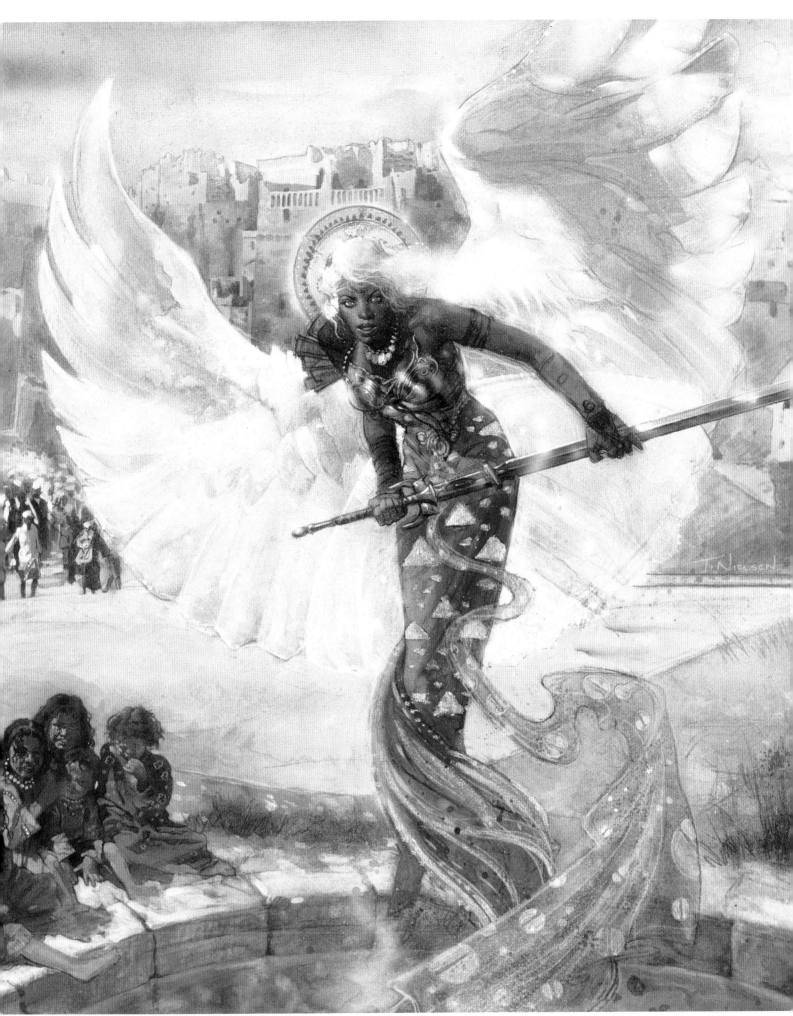

Rose O'Neill 1874-1944

"I am in love with magic and monsters, and the drama of form emerging from the formless."

—*Rose O'Neill*

Among her many other self-taught accomplishments, Rose O'Neill is acknowledged as the first American women cartoonist (with her 1896 strip "The Old Subscriber" for *True* magazine). Though she originally signed her work "C.R.O." to hide that she was female, she quickly stepped into the limelight under her own name as she began producing art for *Puck, Colliers, Harpers* and other prominent magazines of the day. Her comic strip "The Kewpies" led to the creation of the Kewpie Doll (which made her a millionaire). Rose drew over 100 advertisements for Jell-O, exhibited her paintings and life-size sculptures (including her "Sweet Monsters" series) in Paris, and, for a time, was the highest paid and most popular illustrator in America.

A free-spirited eccentric known as the "Queen of Bohemian Society," Rose was often described as "one of the world's five most beautiful women"; she was married and divorced twice. She became a supporter of less fortunate artists (for a time any illustrator needing a meal could mention her name and dine at her expense at the Waldorf Astoria) and a women's rights advocate. Her properties included Bonniebrook in the Ozarks, Castle Carabas in Connecticut, Villa Narcissus on the Isle of Capri, Italy, and an apartment in Washington Square in Greenwich Village that inspired the song "Rose of Washington Square." An extravagant life style, the Great Depression, and finally a change in public tastes (which resulted in a loss of commercial assignments) exhausted her bank account and, impoverished, she lived with relatives in Missouri from 1936 till her death in 1944 from a heart attack at age 69

The College of the Ozarks is the home of a large collection of her work and a museum devoted to Rose is operated by the Bonnibrook Historical Society in Walnut Shade, MO.

www.roseoneill.org

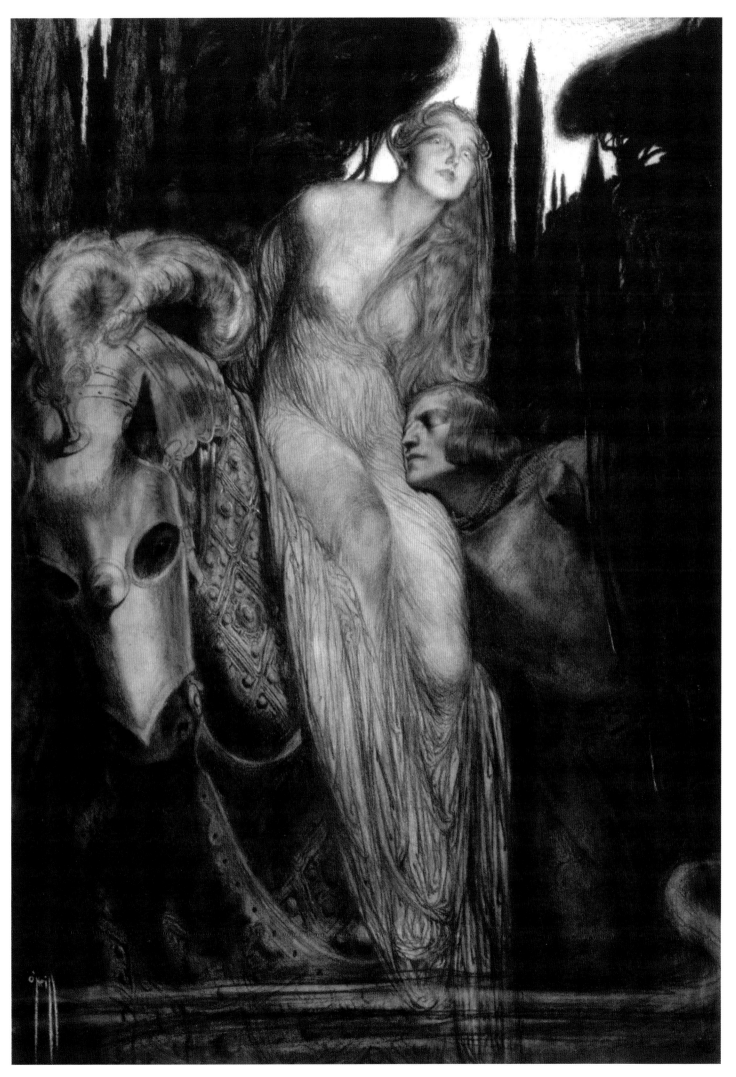

Karla Ortiz

"Lately, I've been thinking a lot about what it means to be an Illustrator. The first answer that came to mind went something like this:

"'Well, I love to be able to paint all kind of insane imagery that does not exist. To jump into the world of wizards, knights, zombies, rogues, elves, space people, aliens, monsters and be able to make them exist in our world?! HECK YES, WHAT A TREAT!'

"But that's not what it means to be an illustrator.

"Then the second answer came 'Well, I get to be a part of an incredible community of passionate folks, who are fascinated by art and the fantastic! We can all sit down and talk about books, games, television, movies, and in some ways influence the sci fi/ fantasy genre with our art! Together all of us can make diverse and interesting imaginary worlds! That's AWESOME!~'

"Very close, but in my heart I knew that's not what it meant to be an illustrator.

"Then late one night, with a cup of wine and a new painting in front of me, the answer came: To be an illustrator is to be an artist!

"To engage in the act of drawing and painting ANYTHING at all, is an incredible blessing. The moment in which you bring out your pencils, brushes or Wacom pens, and from marks emerge a face, a hand, a tree, a waterfall, armor, a dragon, anything at all! That moment, you take a deep breath and realize we are indeed extremely lucky to be able to engage in such an incredible craft.

"So very few of us in this world get to take a moment, and truly gasp at how visually amazing our surroundings are. It is our profession, our duty, to take a moment to observe and ponder the world around us. We reflect on what it is the experience to be alive, and we transfer those thoughts into a canvas. And there is nothing better in the world for me.

"To be an illustrator, is to be an artist, and to be an artist is to truly be alive in this visual world of ours."

—*Karla Ortiz*

www.karlaortizart.com

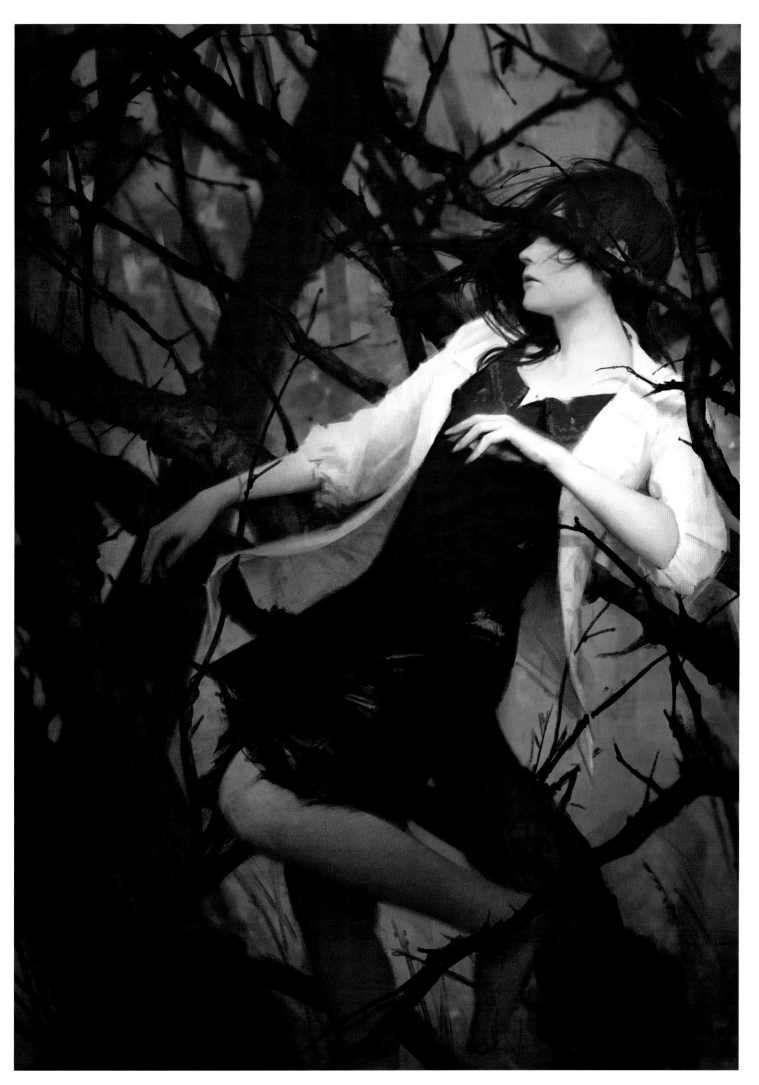

Forest Rogers

"I studied stage design at Carnegie-Mellon University in Pittsburgh, PA, receiving an MFA in Costume Design. I make critters, both 'fine' and commercial."

—*Forest Rogers*

www.forestrogers.com

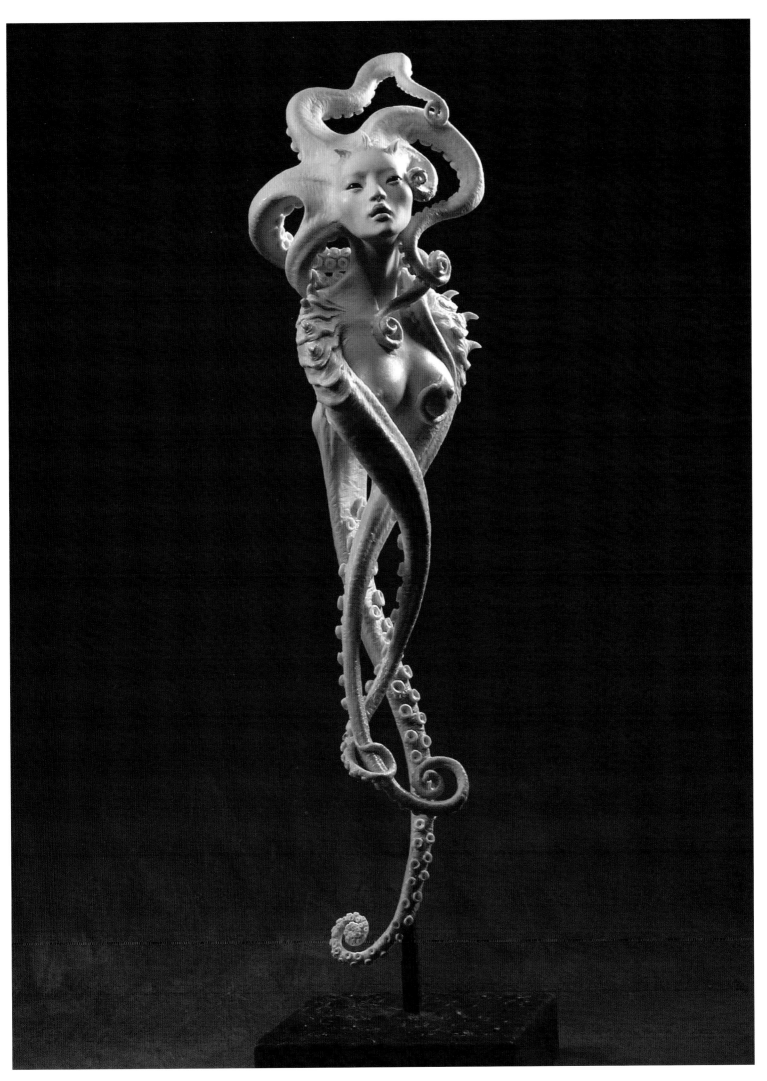

Photo by & copyright © Greg Preston/Spectrum Fantastic Art Live

Virginie Ropars

"For as long as I remember Fantastic Art has always been the main playground in my life, even with non-creative activities.

"I like when things are normal in a first place, then a slightly twisted detail opens a window to another world. I can only give a glimpse to the other world in my work; it's different from the progression a book or a movie offers for instance.

"Fantastic Art to me is a dangerous land to explore, and if not it loses its interest. I need to feel myself fascinated; mainly it is a way to deal with the ambivalence of things by reshaping ideas, concept, and atmosphere that we always tend to see as black and white—good/bad, life/death, beautiful/ugly, safety/danger etc—and the attraction/repulsion forces which make it all work.

"To me Fantastic Art is always in the middle. Nothing is black and white and I tend to be fascinated in this field by things we think of as good and beautiful but which reveal themselves as dangerous or with things dark and dangerous which are incredibly beautiful.

"If you think about nature it is filled with such types of animals, plants, and lands. That completely fascinates me and Fantastic Art to me is truly the playground for expressing and sharing these subjects."

—*Virginie Ropars*

www.vropars.free.fr
www.facebook.com/pages/VIRGINIE-ROPARS-OFFICIAL

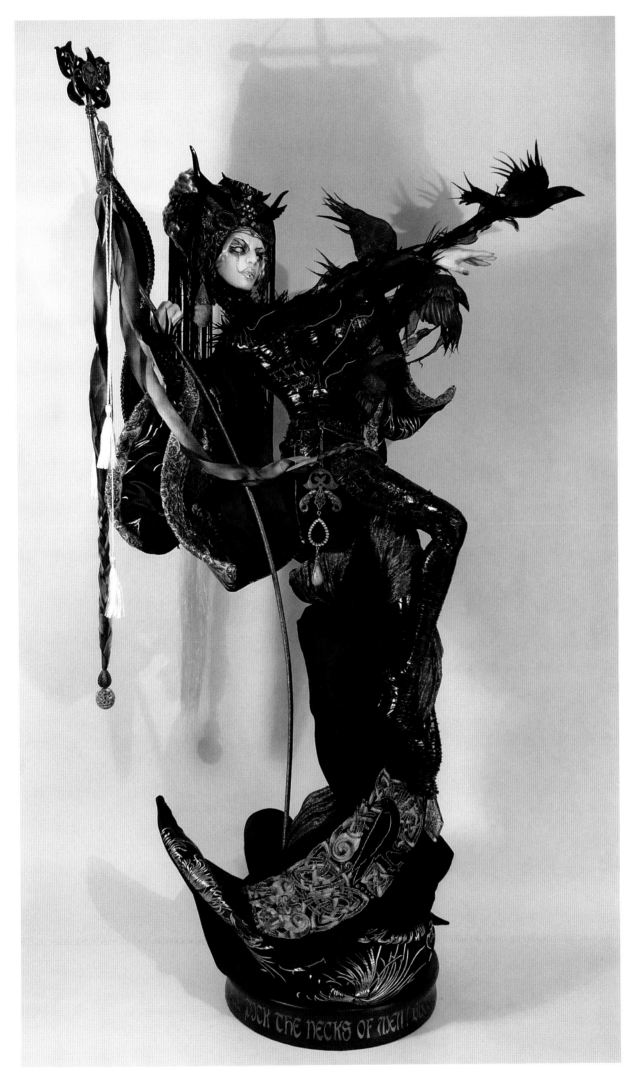

Ruth Sanderson

"I grew up in the 1960's, reading fairytales and then Tolkien, and I am still an avid reader of fantasy. It stands to reason that this is also what I want to paint. I enjoy creating images that depict people, places and things that are symbolic, mythic, and/or fanciful. Images that are not real, but are somehow True. I believe the new and well-named term for this kind of fantasy art is Imaginative Realism.

"Fairy tales can be read and understood on so many levels, which is one of the reasons why I love to illustrate them. In 1985 I illustrated my first fairy tale, *Sleeping Beauty*, which was beautifully retold by Jane Yolen. I was inspired by seeing Paul Zelinsky's beautiful oil paintings in *Hansel and Gretel*, and encouraged by his book to see that it was possible to work in a more traditional and "painterly" style for children's picture books. At that time, more stylized and simple styles were the norm. I wanted to paint pictures that would appeal to all ages, especially since fairy tales were never meant to be for children only. Oils have always been my favorite medium, perfect for the depth and the sense of light that I was planning to depict in the illustrations. Since *Sleeping Beauty* I've gone on to retell and illustrate many fairytales for children, including *The Twelve Dancing Princesses*, *Cinderella*, and *The Snow Princess*.

"The piece reproduced here, 'San Soleil,' is from an original fairy tale by Jane Yolen. It was commissioned for the cover of a collection of her work, *Once Upon a Time, She Said*, published by NESFA Press when she was guest of honor at Boskone, a fantasy convention in Boston. My current project is illustrating a version of a Victorian fairy tale, *The Golden Key* by George MacDonald, a story I have wanted to illustrate for over thirty years. The scratchboard illustrations are a new direction for me, and it is a medium that seems to fit the book quite well.

"There are many fine artists who have influenced my work. Books on the Hudson River Valley landscape painters and the English Pre-Raphaelites are always nearby for inspiration. The beauty of nature inspires me endlessly. Everything an artist looks at goes into the databank of visual reference.

"In addition to creating art, I also love to teach both illustration and writing. I am the co-director of an MFA program in Writing and Illustrating for Children at Hollins University in Roanoke Virginia, which is taken in 6-week residencies over a number of summers."

—*Ruth Sanderson*

Book: *Golden Dreams: The Art of Ruth Sanderson* [Golden Wood Studio]

www.goldenwoodstudio.com

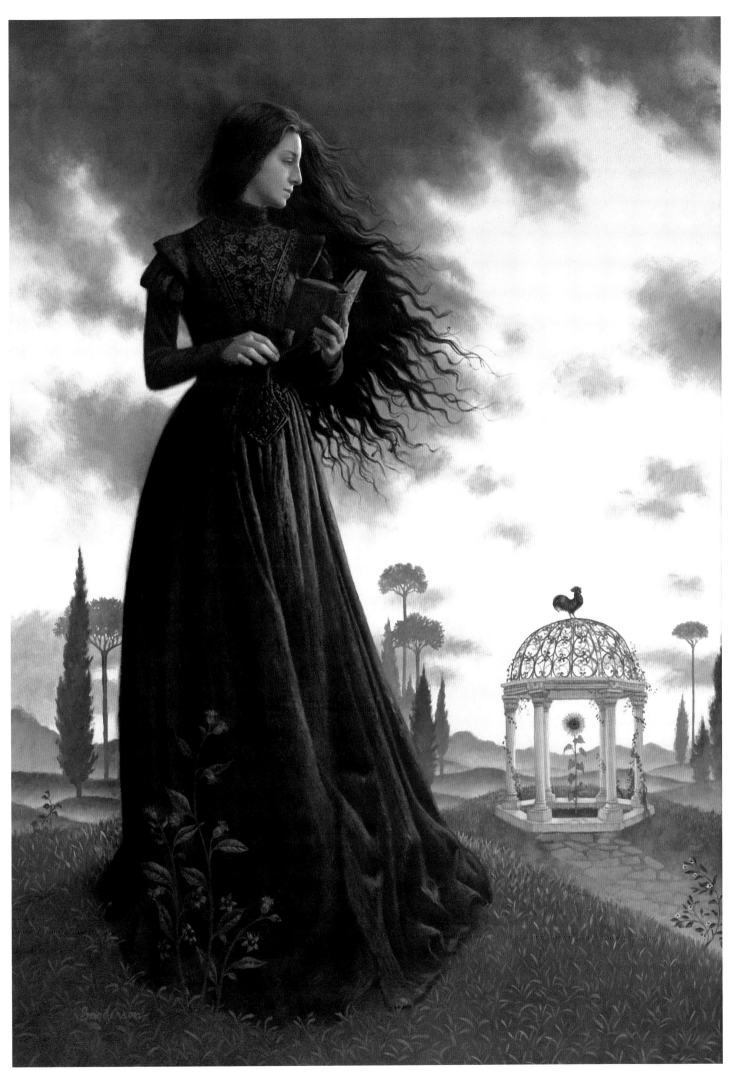

Cynthia Sheppard

Cynthia Sheppard grew up in the VA suburbs of Washington, DC, and despite the climate of politics and technology, she chose a different path and followed her lifelong passion as an artist and fantasy illustrator. Influenced by Romanticism and 19th century painters, she brings that flavor into her latest digital paintings.

Although best known for her illustrations for Wizards of the Coast on Magic: The Gathering cards, Cynthia has worked with a variety of clients including Tor Books, Fantasy Flight Games, Pyr Books, and *ImagineFX*. Her work has also been published in *Spectrum: The Best in Contemporary Fantastic Art*, *Exotique*, and exhibited at Illuxcon, Gallery Nucleus, and Spectrum Fantastic Art Live.

www.sheppard-arts.com

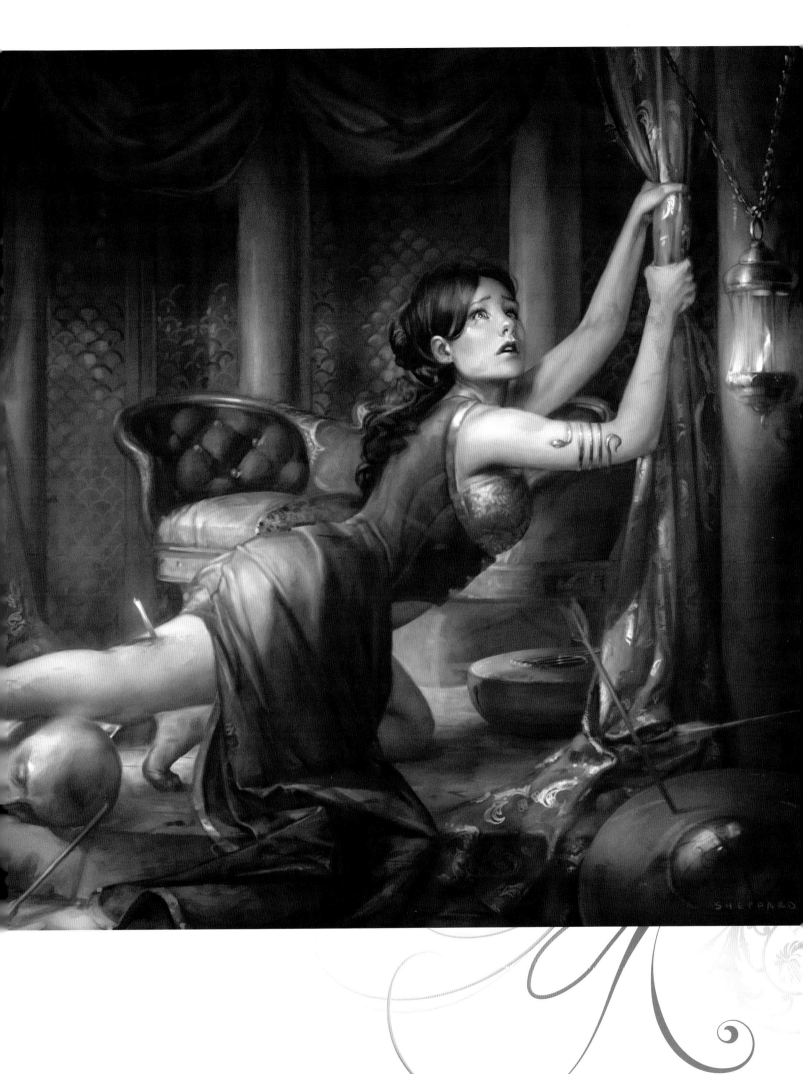

Yuko Shimizu

Yuko Shimizu is a Japanese illustrator based in New York City and instructor at School of Visual Arts. *Newsweek Japan* has chosen Yuko as one of "100 Japanese People The World Respects" in 2009. Her first self-titled monograph was released world-wide from German publisher Gestalten in 2011. The first children's book *Barbed Wire Baseball* (written by Marissa Moss) came out from Abrams in April, 2013.

You may have seen her work on The Gap T-shirts, Pepsi cans, VISA billboards, Microsoft and Target ads, as well as on the book covers of Penguin, Scholastic, DC Comics, and on the pages of *The New York Times*, *Time*, *Rolling Stone*, *The New Yorker* and in many other publications over last ten years.

But illustration is actually Yuko's second career. Although art has always been her passion, she had initially chosen a more practical path of studying advertising and marketing at Waseda University and took a job in corporate PR in Tokyo. It never quite made her happy. At age 22, she was in mid-life crisis.

Yuko ended up working the corporate job for 11 years so she could figure out what she really wanted in life as well as to save up just enough to play a biggest gamble of her life: she moved to New York City in 1999 (where she had briefly spent her childhood) to study art for the first time. Yuko graduated with MFA from SVA's Illustration as Visual Essay Program in 2003 and has been illustrating since. She has also been teaching the next generation of talents at the alma mater.

She works at her studio in midtown Manhattan, and fulfills her passion of world travel by giving lectures and workshops around the world and various cities in the U.S. She has not gotten into mid-life crisis since she has become an artist.

Please do not mix her up with another Yuko Shimizu. *This* Yuko did *not* create Hello Kitty.

www.yukoart.com

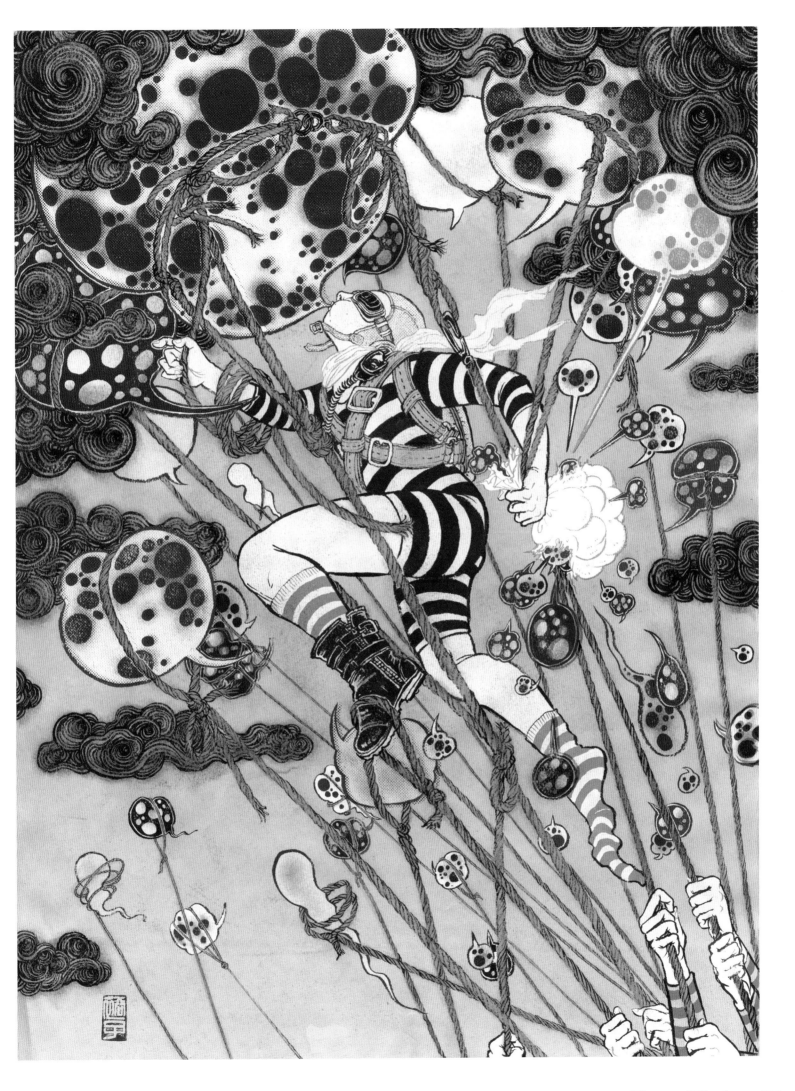

Annie Stegg

Annie Stegg has always loved to paint. Her art career began at 7 years old, when she had first art show at her school. Since then she has never stopped painting and has worked for clients across the world.

Inspired by nature, folklore and mythology, her work evokes emotion and imagination in the viewer.

Annie has a special love for the 18th century Rococo painters who have had a large influence on her own method. She finds inspiration in their imagination, and the dreamlike palette and lively brushwork that combine to create a wonderful atmosphere of enchantment. She believes that they sought to transport us to different worlds and fantastic places though their works. In her own work, known for it's beautiful, enigmatic figures and lively creatures, Annie strives to depict this same transportive effect to the viewer.

She and her husband live in Northern Georgia with their dog and two cats.

www.anniestegg.com
www.facebook.com/AnnieSteggFineArt

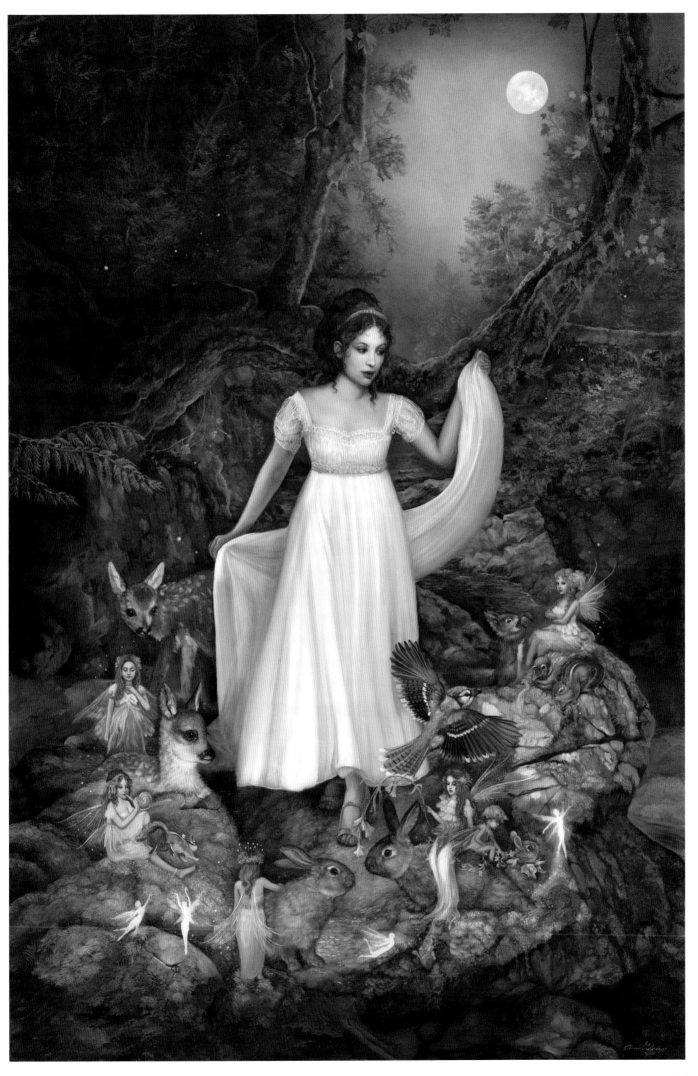

Heather Theurer

Heather's paintings are the product of decades of observation of people, environments, animals and textiles. Although she was not able to obtain a formal education in art, all her studies of the natural world in addition to the works of great artists including the renaissance masters, the Pre-Raphaelites of the late 19th century and modern masters have influenced he work in a way she couldn't imagine getting in a classroom.

Themes in her work include religious symbolism, fantasy realism, equine and wildlife, and bold reworking of Disney characters. Her process in painting is constantly morphing as she applies new techniques, but most often consist of a multitude layers of paint and glazes (as many as 20 or more in some cases) to reach the desired depth and detail that dominates her work.

Shared and collected around the world, Heather Theurer's paintings are constructed in the midst of a bustling family with five children in Las Vegas, Nevada. Regardless of the challenges, her art has gone on to get the attention of *USA Today* and the *LA Times*, garnered contracts with Disney Fine Art and Fantasy Con, and received recognition and awards from respected organizations such as Art Renewal Center, *Artist's Magazine* and *Spectrum: The Best in Contemporary Fantastic Art*, among others.

www.heathertheurer.com

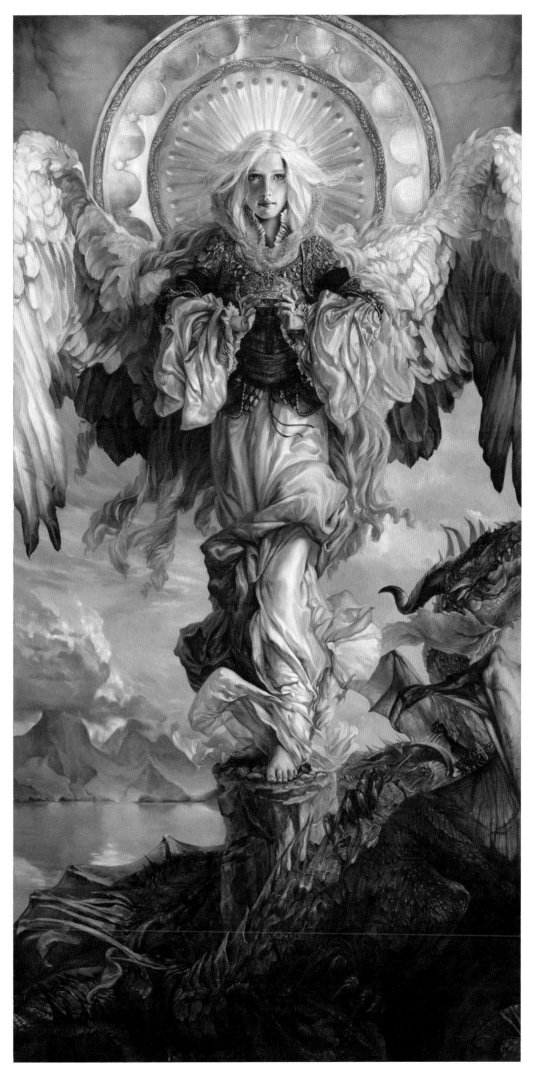

Shelly Wan

"My artistic journey is one that focuses on self-understanding and discovery: I can never stop looking for what moves me in art. This is what makes life meaningful for me out of the chaos. Different genres of art speak to me, but Symbolism and Orientalism have always stood out to me as the more interesting genres. They combine the mundane, the age old myths and the exotic/unknown, and somehow that's the place my heart always yearns for. These types of art have been a lighthouse for me to navigate my own life, they lend me knowledge of artists past, taught me to be at peace with the singular, unrepeatable moment, the imperfect perfection and the worthy pursuit of creating pieces that embodies the same values, for other generations to come."

—*Shelly Wan*

www.shellywan.blogspot.com/
www.facebook.com/shellyminwan
www.instagram.com/shelly_wan

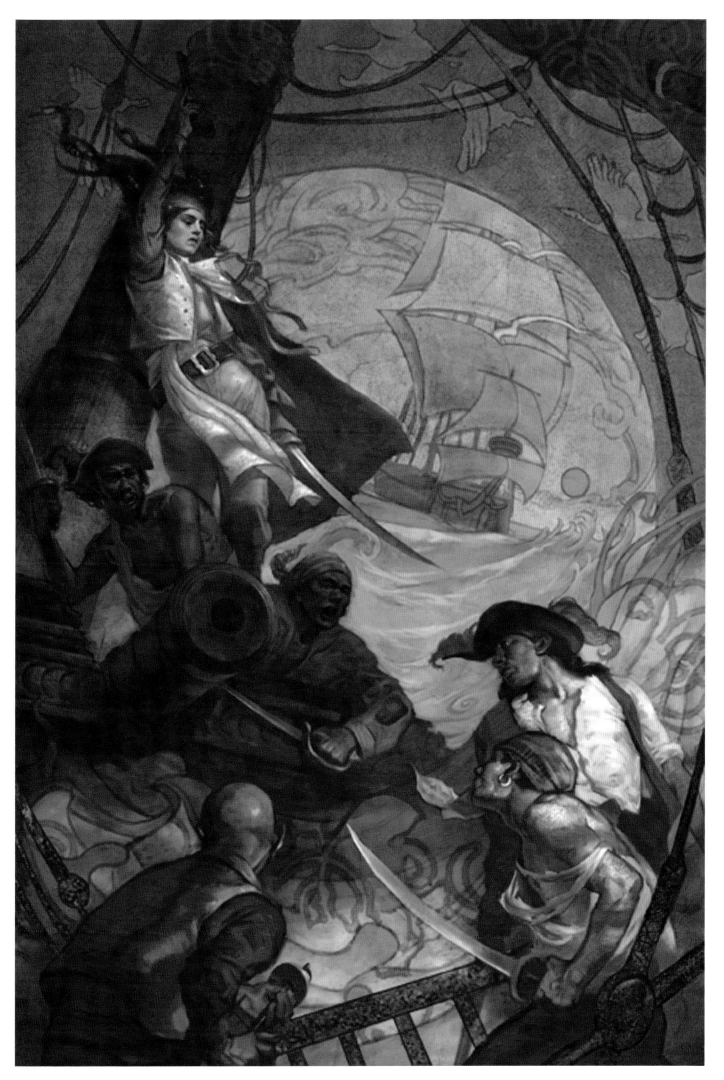

Heather Watts

"My work is rooted in my own inner world, a world of feeling, imagination, soul and emotion.

"There's a constancy to this realm that can be hard to find in the outer world. Through time and across space, our external experiences—our cultures, environments, religions and appearances—are vastly different, but facets of our inner life transcend these differences. No matter where or when we live or what we believe, almost all of us share a common experience in our capacity to feel. The joys, fears, hurts, loves, hopes, dreams and infinite other emotional twists of our inner lives aren't bound by time or space, or by the constraints of physical reality.

"The imagery of fantastic art is similarly boundless. Strange and otherworldly, mythical and mystical, symbolic and surreal, it's an encyclopedic visual language that can be written in infinite hands, with infinite contexts and infinite interpretations. It is imagination unleashed, a well of collective consciousness and memory filled with anything anyone has ever experienced or dreamed up. It is the limitless possibility within which I find the tools I need to express the overwhelming intensity of inner experience in a way that others can appreciate and find meaning in."

—*Heather Watts*

University of British Columbia BA

www.heatherwatts.com

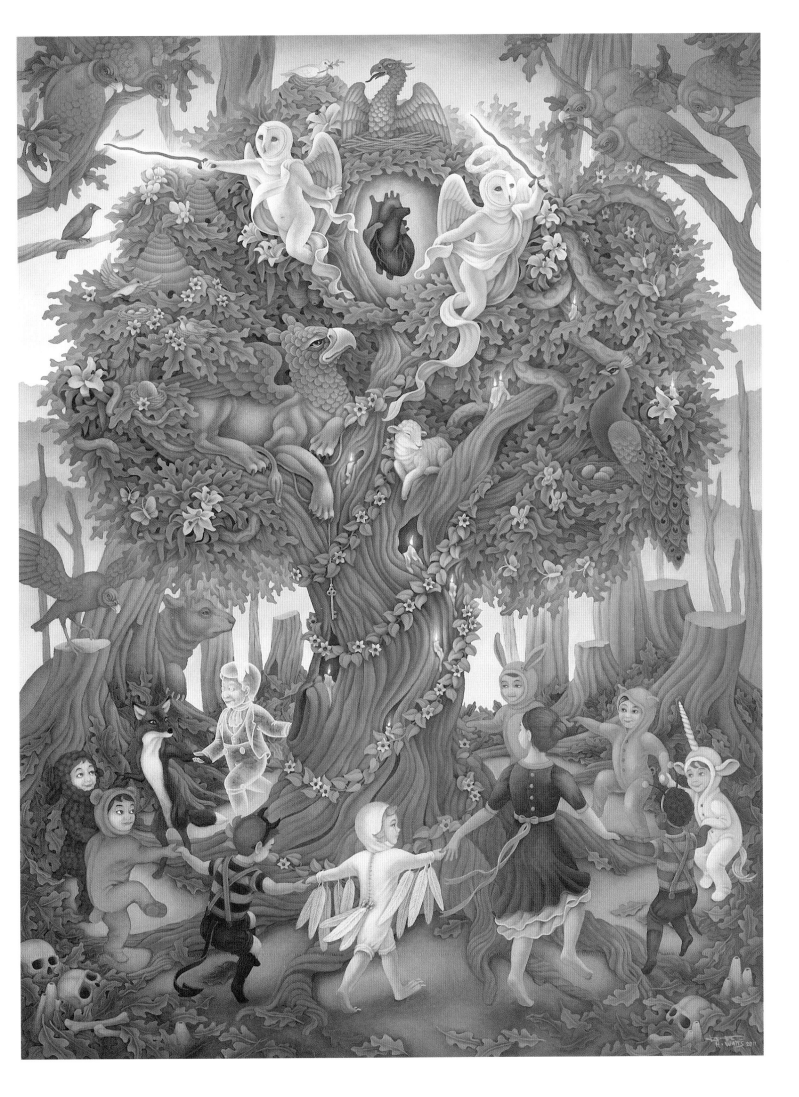

Claire Wendling

"As artists, we're all the same; we all start out with the same blank piece of paper and accept the challenge to fill it. When we're young we're envious of what we see others do and want to learn how they achieved it. When we're older we see younger artists producing amazing things and want to keep improving so that we can continue to produce amazing things, too."

—*Claire Wendling*

Book: *Daisies* [Soleil]
Book: *Aphrodite* [Humanoids, Inc.]

www.claire-wendling.net

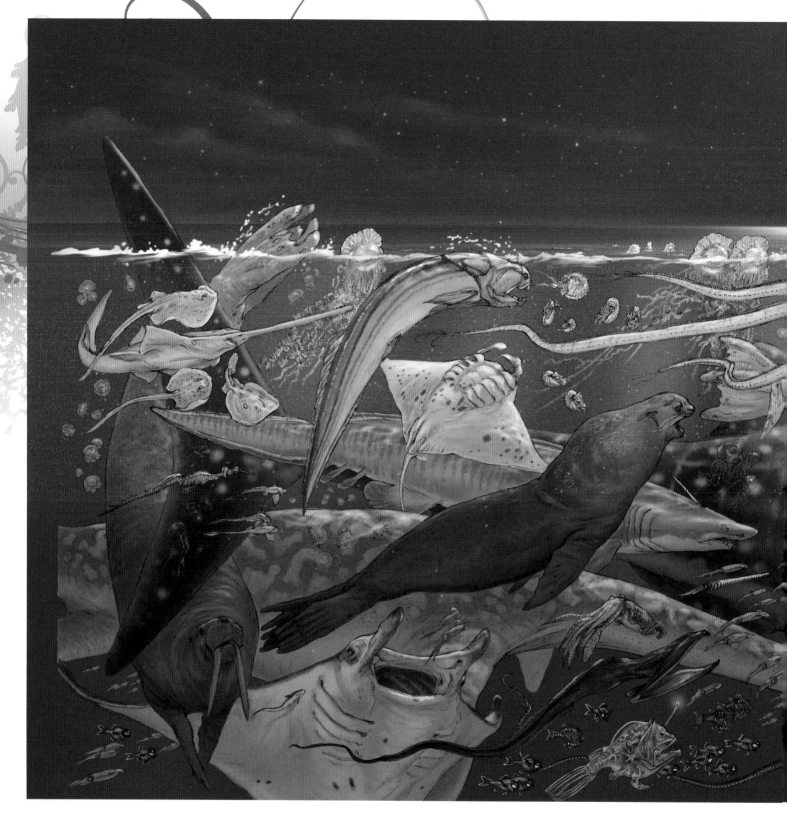

Terryl Whitlatch

"Animals have so much to teach an artist—to appreciate and be awestruck by their sheer variations in form and anatomy, to try to look at the world from out of non-human eyes, and thus glimpse previously unimagined horizons and doors into other dimensions and universes. And ever and ever, animals will always surprise you. Having designed imaginary creatures professionally for over three decades, in comparison such creature design is relatively easy, almost an adjunct science, for invented beings have no living fellows in nature to be measured with. It is the real animals who show me that I still have so much to learn, more than several lifetimes, and into infinity."

—*Terryl Whitlatch*

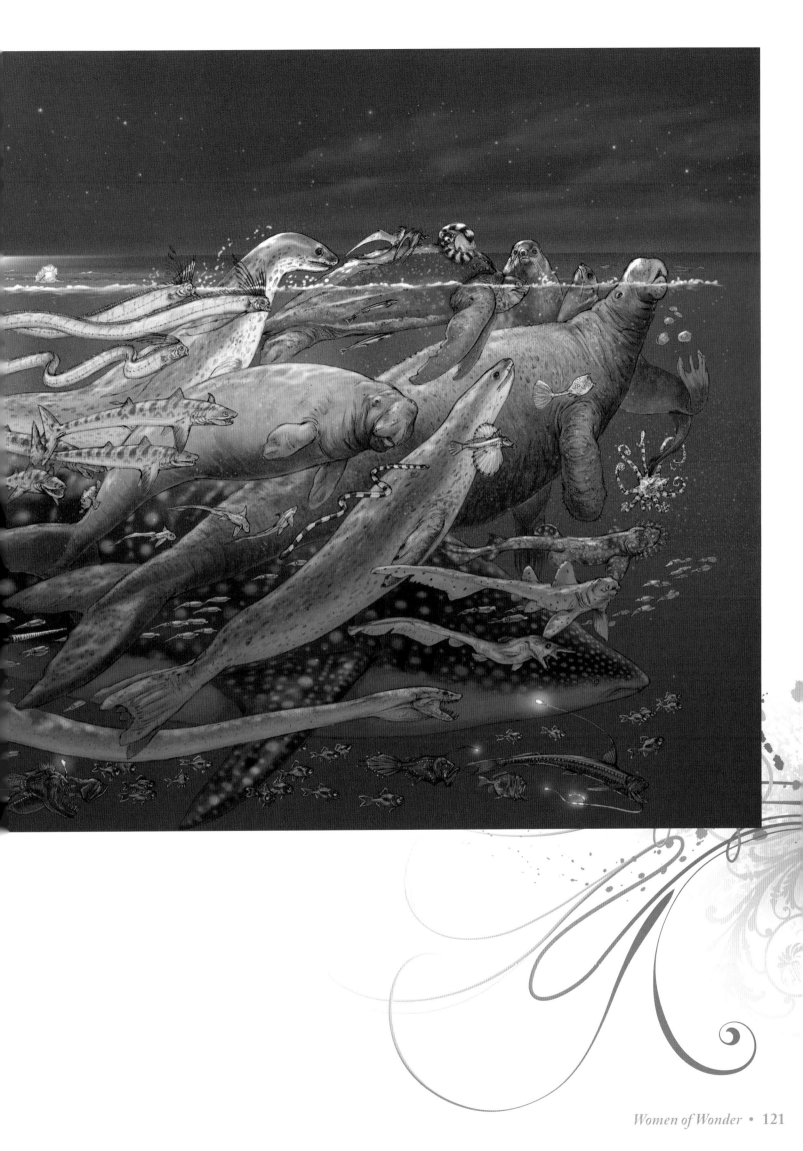

Sulamith Wülfing 1901-1989

"My drawings are a visual representation of my deepest feelings - pleasure, fear, sorrow, happiness, humor. And, to people attuned to my compositions, they may well be mirrors of their own experiences. It is because of this that I have left the explanation of the drawings completely to the viewer, so that they are not bound by my interpretation of what each picture should be.

"For me it is not a matter of creating illustrations to fit nursery rhyme themes. My ideas come to me from many sources, and in such harmony with my personal experiences that I can turn them into these fairy compositions.

"My Angels are my consolers, leaders, companions, guards. And dwarfs often show me the small ironies and other things to make me smile even in life's most awesome events."

—Sulamith Wülfing

Sulamith Wülfing was born in Elberfeld, Rhine Province and as a child was said to have visions of angels, fairies, gnomes, and nature sprites: she first began drawing these creatures at the age of four. The visions continued throughout her life and she said directly inspired her paintings. Wülfing graduated from the Art College in Wuppertal in 1921 and in 1932 married Otto Schulze, a professor at the school. Together, they created the Sulamith Wülfing Verlag (publishing house). During World War II, while her husband was away in the German Army, the industrial area around Wuppertal became a bombing target and Sulamith's house was destroyed along with many of her paintings. When she received a false report of Otto's death on the Russian front she fled to France with their only child; the family was later reunited after the war. Sulamith returned to publishing and continued to create new works until her death in 1989 at the age of 88.

Book: *The Fantastic Art of Sulamith Wülfing* edited by David Larkin [Peacock Press]

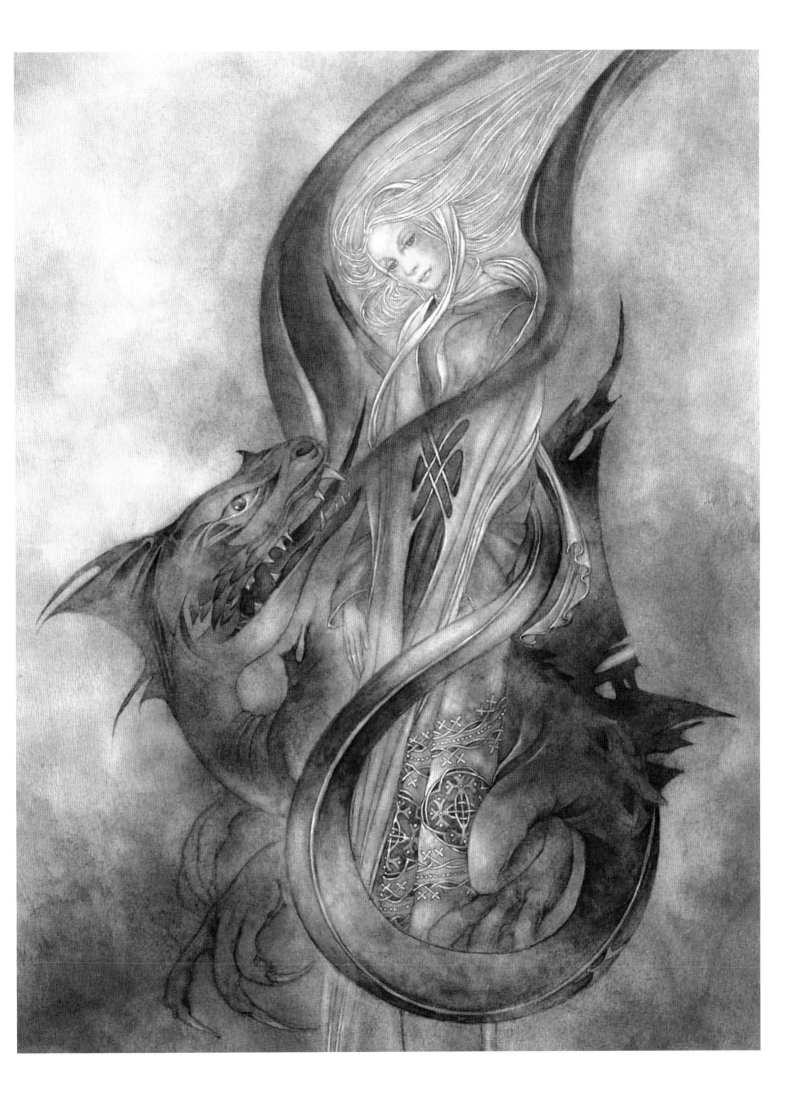

Rebecca Yanovskaya

Rebecca Yanovskaya is a freelance illustrator working in the fantasy, sci-fi and horror genres. She frequently illustrates mythological stories, natural forces, and aesthetically strong characters. Rebecca's influences include decorative arts, neoclassical and Pre-Raphaelite arts, and theatrical costuming. Despite most artists in her genre using digital and traditional painting tools, she has made the choice to construct her pieces with ballpoint pen and gold leaf. As one of the only primarily ballpoint pen artists working in fantastic realism, her work is easy to identify. A combination of epic scope and moody atmosphere define her signature style, in what can be described as the "Art of the Sublime".

Rebecca is a graduate of the Illustration program at Sheridan College. She lives and works in Toronto, Canada.

www.rebeccayanovskaya.com

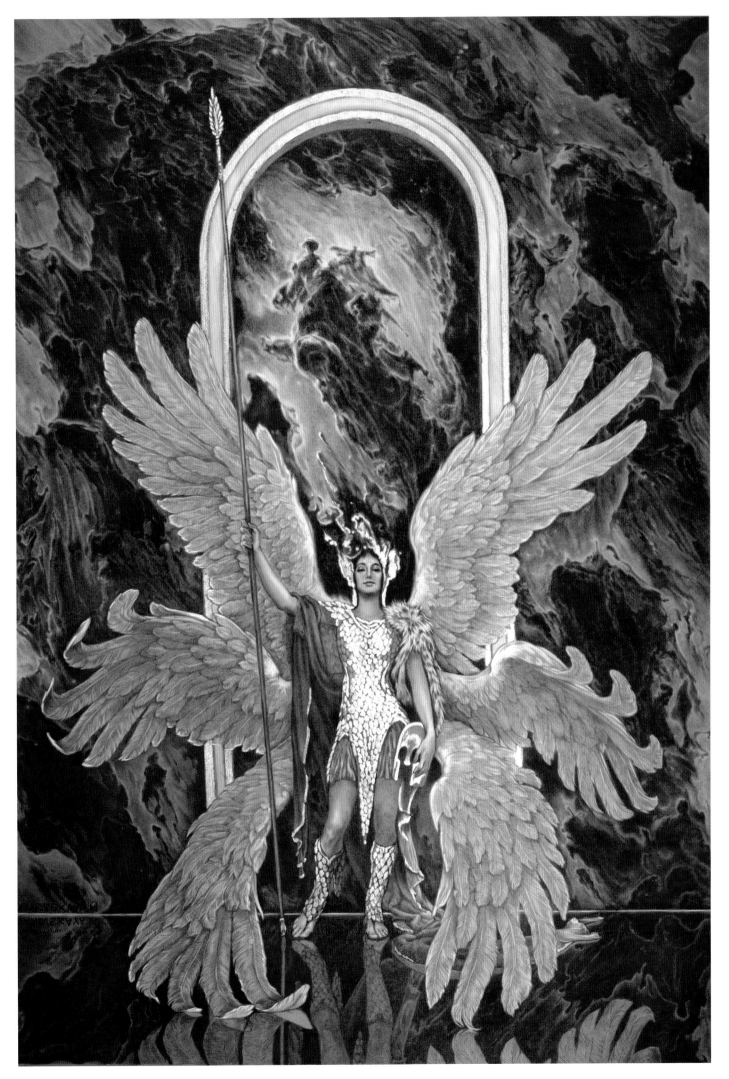

Chie Yoshii

"Painting for me is 'participation mystique.' It is not about reality, but about the fantasies aroused by it's effects. They are viscerally conceived and more tangible than reality.

"I believe certain experiences resonate with archetypes in my collective unconscious; universal, inherited parts of the mind that bring these images to the surface of my consciousness. They construct surreal pictures in my mind as translations of these particular experiences.

"In my paintings, I actualize this mythical inner reality. The process reassures and grounds me by connecting me to a collective psyche that is beyond time and location."

—*Chie Yoshii*

www.chieyoshii.com

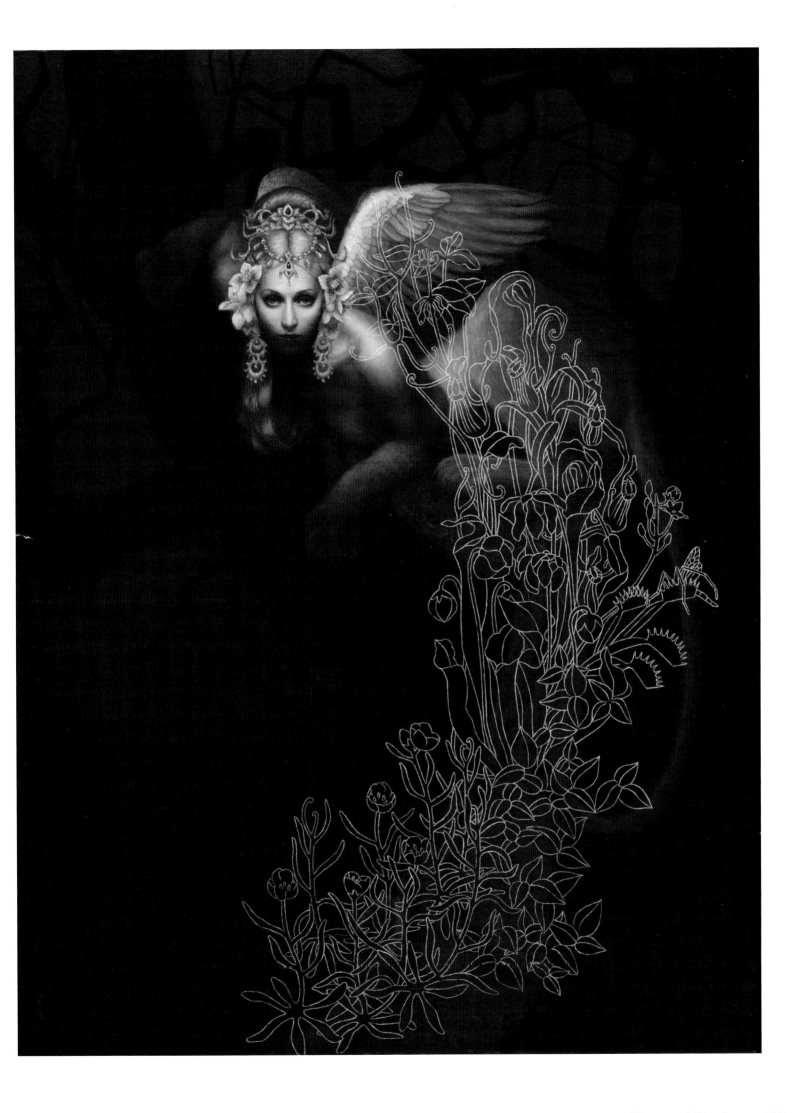

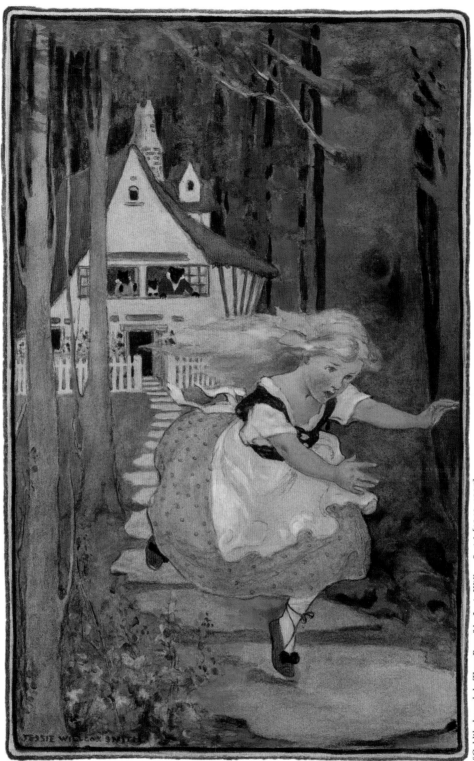

"Goldilocks and the Three Bears" by Jessie Willcox Smith [1863-1935]

About the Editor Cathy Fenner

Cathy Fenner worked as an artist for Hallmark Cards for over 30 years, producing all manner of products in the "personal expressions" field. With her husband Arnie she is the cocreator of the annual *Spectrum: The Best in Contemporary Fantastic Art* as well as the artist-focused convention, Spectrum Fantastic Art Live. Cathy has coedited books devoted to the works of Frank Frazetta, Jeffrey Jones, Robert E. McGinnis, and many others. *Photo by Greg Preston.*

About the Introduction Author Lauren Panepinto

After 11 years designing and art directing book covers, Lauren Panepinto has worked in every publishing genre and collaborated with artists as varied as Shepard Fairey and John Harris. As the Creative Director of Orbit Books and Yen Press for the past five years, she has been trying to merge the worlds of genre and commercial publishing and figure out what SFF publishing looks like in the present world of mainstream "geek" media.